A BOOK BY
ANSELM KIEFER

A BOOK BY ANSELM KIEFER

FOREWORD BY JÜRGEN HARTEN

INTRODUCTION BY

THEODORE E. STEBBINS, JR. & SUSAN CRAGG RICCI

THE MUSEUM OF FINE ARTS, BOSTON
IN ASSOCIATION WITH
GEORGE BRAZILLER, PUBLISHERS

Published in the
United States of America by
George Braziller, Inc. and
The Museum of Fine Arts, Boston

Photography by
Wingate Paine for
Brunhilde and Her Fate
by kind permission of John White

For information
address the publisher:
George Braziller, Inc.
60 Madison Avenue
New York NY 10010

**Library of Congress
Cataloging-in-Publication Data**

Kiefer, Anselm, 1945–
 A Book by Anslem Kiefer.

 "Text by Jürgen Harten
translated from the German"
– – Bibliography: p.
 1. Kiefer, Anselm, 1945-
– – Notebooks, sketchbooks, etc.
 2. Kiefer, Anselm, 1945-
– – Criticism and Interpretation
 3. Watercolor Painting
– – Germany (West)
 4. Watercolor Painting
– – 20th century – – Germany (West)

I. Stebbins, Theodore E. II. Harten, Jürgen.
III. Museum of Fine Arts, Boston. IV. Title.
ND1954.K43A4 1988 759.3 87.21210
ISBN 0-8076-1191-3

Printed and bound in Japan
by Toppan Printing Company
Designed by
Anthony McCall Associates, New York

First Printing

TABLE OF CONTENTS

DEDICATION

This book has been made possible
by the kind cooperation of
Anselm Kiefer
and the generosity of
Hon. H. John Heinz III

ACKNOWLEDGEMENTS

We acknowledge with special thanks the contributions
made to this book by Michelle O'Malley, Carl Zahn,
Trevor Fairbrother, and Harriet Rome Pemstein.
The excellent photography has been provided by John Lutsch
of the Museum of Fine Arts, Boston
and the text has been ably edited by Beatrice Rehl.
In addition, we are most grateful for the very kind assistance
of Anthony d'Offay and Marian Goodman.

T.E.S., JR. & S.C.R.

PUBLISHER'S PREFACE

During the past few years, I have admired the modern "artist's book" as an art form. In the first decades of the twentieth century, such figures as Vollard, Tériade, and Iliazd, among others, perceptively recognized that format, design and typography could be integrated with text and illustrations to create a completely different kind of book — indeed, a new kind of art. In close collaboration with artists and writers, they produced some of the extraordinary illustrated works of the modern period.

When I first became acquainted with Anselm Kiefer's book *Erotik im Fernen Osten oder: Transition from cool to warm*, I realized that his work stands outside this newly established tradition of book making. It is, rather, a unique volume: devoid of text, not intended as a "de luxe" edition, it is a pictorial drama that takes place between two covers. Overwhelmed by its brilliant colors and startling images, I decided to publish an edition of this book. What I found to be most challenging in this endeavor has been finding a design concept that would graphically capture the spirit of the original work of art. The artist, who has a special affinity for the book from having completed more than one hundred works in this medium, was not interested in a true facsimile, as he felt it would misrepresent the character and intent of the original. It was Kiefer, in fact, who suggested that this edition be a "book about a book" and he participated in its evolution. Keeping his concerns in mind, we worked to convey a sense of visual journey — one that both parallels and echoes the images contained on its pages. Indeed, we have worked to create a publication, which, like Kiefer's own book production, confirms the vitality of the book as a medium that still has meaning to the contemporary creative spirit. ∎

PREFACE

BY JÜRGEN HARTEN

Anselm Kiefer is one of the most successful — if controversial — artists in the world today. There are many reasons for the controversy surrounding his work, among them the envy of less successful artists. The broader art public continues to debate the specifically German aspects of his work as well. It is therefore important to remember that until recently, this pointedly German subject matter was practically taboo.

With the exception of the filmmaker Jürgen Syberberg, no artist working after 1968 has so knowingly used German subject matter as Anselm Kiefer. Lacking aesthetic inhibitions, he has radically challenged the narrow moral judgment of German history as no other artist has done. But if Kiefer seemed to make the unbearable possible in aesthetic terms, his intentions were, at first, probably neither critically therapeutic nor particularly morbid. One can easily imagine that the horrific, the utterly mad, the truly ungraspable had to be understood, depicted, and, if not fully explained, at least made visible: from "the darkness of the lived moment," which Kiefer hinted at in one of his early books through a potato printing block set in the "eye" of a palette, to the sober emanations in the sign of Saturn. It is *art* as myth to which Kiefer gives expression in historical terms, when he dedicates grandiose, ruined monuments to "the unknown painter," an analogy, of course, to "the unknown soldier." He searches for the difference between creative renewal and catastrophe in a chain reaction formed by enlightenment, missionary conviction, salvation, and readiness for sacrifice.

In a number of one-man shows held in Germany, Holland, and Switzerland since the early 1970s, Kiefer has attracted attention with pictures that incorporate references to Christian mythology and literary history. But even as late as 1980, when he exhibited with Georg Baselitz in the German pavilion at the 39th Biennale in Venice, critics accused him of treating the Nazi past frivolously by clouding it with German profundity, rather than by reflecting

on alternative means that an artist might use in order to come to terms with recent German history. What they did not acknowledge is that Kiefer often begins with basic themes that are purely German — such as a forest, a field, a room, or a hall — onto which the story to be told can be projected. By giving life to these realities, he effectively marshals an uneasiness triggered by a storehouse of blood and earth, fictional military campaigns in snowy landscapes, and sacrificial rituals from Richard Wagner's repertoire. But what makes Kiefer remarkable as an artist in the German tradition, and as a successor to Joseph Beuys, is the renaissance of the *Erdlebenbilder* or "living earth pictures." Carl Gustav Carus once so called the landscapes of the great Romantic painter Caspar David Friedrich to suggest that the landscapes were infused with both real and symbolic vitality. In this sense Kiefer's "earthscapes" take on fluxus aspects: his entry at the 1980 Biennale, for example, was entitled *Verbrennen, Verholzen, Versenken, Versanden.*

Although Kiefer's work was at first considered as part of the "new German painting" the artist had, in fact, been developing independently from the very beginning. Kiefer has never belonged to any of the Neo-Expressionist groups, although some of his pictures were shown with theirs in traveling exhibitions. Like all twentieth-century artists, he had first to find, and then to affirm, his subject matter, so that today we can look at a body of work of almost epic continuity. He has created a series of works utilizing symbols from Nordic and Near Eastern mythology as well as from Dionysius the Aereopagite and the Cabala, although they do not narrowly correspond to the mythological subject matter of the former or the spiritual orders of the latter. Rather, the series grew out of certain pictorial inventions, which in turn allow traditional iconographic elements to have variable meaning. In an essay that appeared in the magazine *Artstudio* during the autumn of 1986, Doreet LeVitte-Harten compared Kiefer's pictures, and his pictures of pictures, to images with

cabalistic emanations whose messages could be interpreted as somewhere between gnosis and science fiction. According to this theory, Kiefer could have progressed from art as myth (itself the subject of painting) to testing a mythological concept through the very act of painting.

By interpreting the term *series* with caution, one might say that Kiefer's works were hardly planned to be consecutive but are the result of ongoing artistic aims which, sometimes after long interruptions, he has bent to similar starting points. As if we were turning the pages of a book, the pictures are kept in motion and are always open to semantic shifts. It is therefore no coincidence that Kiefer should have adopted the book as an artistic medium. From the paper binders that he himself made, which include sketches based on cheap erotic poetry, to the heavy tomes in chtonic mixed media, these unique books assume an important place in his oeuvre. They were never intended for reproduction; those that have been published have always been compiled according to his instructions.

To look at the collection of watercolors reproduced here is to behold enchanting improvisation. The seductive poetry of this self-contained, apparently naive painting does not immediately reveal that Kiefer has actually created pictures from the commonplace. Here is a ship of dreams, glittering under the mountains, as in a fairy tale; here is Brunhilde, synonymous with the tragedy of passionate surrender, seemingly born again from commercially erotic poses. And everywhere are transitions at once familiar and unfamiliar: the messenger of the sea between arrival and departure, fantasy in the imagined absence of corporeality, pictures emerging in the efflorescent pigment of flowing color. ∎

INTRODUCTION

BY THEODORE E. STEBBINS, JR.
& SUSAN CRAGG RICCI

To open Anselm Kiefer's small book *Erotik im Fernen Osten oder: Transition from cool to warm* is a magical experience. Inside we find a series of watercolors that are fresh and spontaneous, but which have obviously been planned as parts of a complex whole. With Kiefer, we are used to works seemingly made for giants: huge paintings encrusted with debris, rocks, straw, propellers, and the like protruding from their surfaces; or oversized books with thick, heavy pages made from woodcuts, photographs, or even lead. When one thinks of Kiefer, one thinks of the blackness of these works, their evocation of fire and destruction, and their exploration of history and myth. But in this book, the artist reveals another side of himself, for it has a completely personal, private quality. Now one comes face-to-face with Kiefer at his most intimate, as he works delicately and quickly in pure watercolor—a medium for which he is little known—and as he executes colorful landscapes, seascapes, and, most unexpected of all, an astonishing series of female nudes.

Though the book will surprise many, everything about it is consistent with Kiefer as revealed in his large works and his other books. Like all his work, this book is complex and multilayered, despite its seeming simplicity. It should not be admired for its beauty alone, because an understanding of the ideas surrounding it will help us to appreciate it more fully and to know the artist better. This is not to say that the book can be easily explained, or that it follows a single program, for Kiefer's work always defies simple analysis. This book, a private object by its very nature, best explains itself. Only one person at a time can see it satisfactorily, and it must be examined at one's own pace. It is meant to be held on one's lap or placed on one's desk so that one can make contact with its materials as each page is turned. The book has a magical quality of its own, an internal energy that cannot be intellectualized or analyzed art-historically, or even reproduced satisfactorily. And yet, paradoxically, this book is somehow so unique and so lyrical that it demands to be shared.

During the summer of 1974, Kiefer made a long trip by automobile from Germany to Norway's North Cape, the northernmost part of that country's landmass. This was his own instinctive search for the roots and the very locale of the Norse legends that had captivated him. Thomas Carlyle described the Nibelung land as follows: "Far beyond the firm horizon, that wonder-bearing region swims on the infinite waters, at most discerned as a faint streak hanging in the blue depths, uncertain whether island or cloud."[1] This cold and sparsely populated area, a region of fjords and icy rivers and one of immense beauty, is the subject of the first part of *Erotik im Fernen Osten*. On his trip, Kiefer made numerous Polaroid photographs of the topography he saw, as well as of icebergs, sunsets, ships, and the like, and it is these photographs (along with postcards that he acquired along the way) that served as *aides-memoires* when he made the book three years later. Thus the first part of Kiefer's volume, devoted as it is to the northern landscape and its atmospheric effects, relates to those illustrated journals in which nineteenth-century painters recorded topographical wonders and other sights they encountered on their long sketching tours. But Kiefer is very much an artist of the late twentieth century, and this work of art is far more than a traditional artist's sketchbook.

The book is outwardly unprepossessing, of modest size yet considerable thickness, and it has a commonplace gray paper cover. On it, Anselm Kiefer has inscribed his title: *Erotik im Fernen Osten oder: Transition from cool to warm* ("erotic in the Far East or: transition from cool to warm"). There are ink spots and stains on the margins, and unless one knew otherwise, one might guess it to be a notebook of a university student. Holding the book, one notices that it is light in weight and soft to the touch. Yet, though smaller and more fragile than Kiefer's better-known books, this book shares with them an indefinable quality of being somehow venerable and deeply symbolic.

Kiefer's bilingual title provides the first (and most obvious) of many dualities inherent in the book. The first half of the title is in German, the second half in English; and both halves contain a mixture of truth and irony. *Erotik im Fernen Osten* ("Erotic in the Far East") is puzzling, for while there are drawings here that could be considered erotic, the scene seems to be the Far North, and there is nothing Eastern or Oriental about it. Here, Kiefer apparently had in mind a generic reference to Indian and Japanese books containing erotic material, but he also aimed to give his title a certain ironical quality. As for the English part of the title, "transition from cool to warm," we should recall that the book was done at a time (1977) when the artist's English was minimal. Struggling with a German-English dictionary to find the words, he wanted to suggest his aim that the book have a universal, not only a German, meaning.

"Transition from cool to warm" can thus be understood in several ways. Kiefer's watercolors at the beginning are icy cool landscapes, rendered in blues and blacks. As one goes through the book, there occurs a gradual transition as reds are introduced, the colors become hot, and the subject changes from landscape to the female figure. Kiefer wanted his title to bring to mind Paul Klee's theories about color transition as explained in that artist's *Pedagogical Sketchbook* (1924): he sees his own book, in part, as an ironic commentary on these formal systems. Kiefer may mock the rigidity of the Bauhaus here, but at the same time he puts into practice German color theory going back to Goethe and Runge: his watercolors gradually, almost imperceptibly, grow warmer, until he has made the full transition from the cold seas and skies and icebergs to the full warmth of glowing red sunsets. But color is only one of the artist's tools: equally important is the transition that occurs in subject matter, from the sea to naked female form. Other simultaneous transitions occur as well: the book suggests a seeker's transition from

rationality to passion; a change from geographic to sexual exploration; an attitude that starts as rational and material and becomes visionary and dreamlike; and perhaps a message that begins as personal and then becomes archetypal, mythic, and universal.

Erotik im Fernen Osten includes sixty-five watercolors, followed by more than a hundred empty pages. We are introduced first to a distant view of the dark earth, water, and cloudy sky of Norway's North Cape. On the second page we encounter a large black ship on heavy seas, with a stormy gray sky in the distance; it moves to the left, belching smoke from three large smokestacks. We understand that a tale is going to be told. The scene is set in the waters of the cold North, and we have met the protagonist, or at least his vessel. These first two sheets prepare us for the first half of the book, in which Kiefer develops several themes including the one suggested in his title, the coloristic transition from cool to warm. The transition is gradual, almost imperceptible at times, but never mechanical or regular. As early as the third page, color lightens significantly, with an evocative pale blue sky — stained and blotted and almost suggestive of human form — dominating two-thirds of the sheet, while a dark, flat sea lies below; and a warmer hue, the mauve used on the icebergs in the foreground, is introduced. Three additional pages explore the theme of calm seas and active, magical skies: there is a strong sense here of nature's mysterious powers, of an empty landscape bursting with potentialities.

After the sixth watercolor, Kiefer reintroduces the ship, and five succeeding sheets then show its journey along dark, icy rivers, the ship always moving to the left, the sky again starting to lighten as pale greens show up in it. Then the artist shifts away from the boat and its lonely, inexplicable voyage to a startling vision of a huge, white iceberg in a richly colored mauve, green, and dark blue sea. In this twelfth watercolor, there is a sense of being uplifted, of coming yet closer to nature. Icebergs and fog are

the subjects of five more pages, as the sky lightens in a pale mist, then begins to show blues, then mauves, then pinks. These colors lead to the eighteenth watercolor, which marks a dramatic transition: here the ship reappears, seen more closely; it still steams to the left, but now is silhouetted against a warm sunset sky. The atmosphere is active, colorful, and luminous, and it glows with pale reds, blue-grays, and pale greens and tans. There are rich reflections in the water, and one has a warm sense that a new era is dawning.

What Kiefer has hinted at has now happened: the sun is close to rising. The pictures elicit feelings of anticipation and excitement in our most visceral selves. A primary myth of the Scandinavian Bronze Age concerns the sun's passage across the sky in a chariot by day and its journey under the earth by ship at night. The ship, which carried a fertility deity, and the sun, representing creation and renewal, were both potent symbols dating back to earliest times. Throughout Kiefer's book, we feel hope and renewal; as night turns into day, our primal feelings and aspirations are aroused. In this watercolor and the three that follow, one senses and then sees the birth of the sun. Color grows richer in the nineteenth sheet. The reds, yellows, and oranges in the sky grow more intense; the presence of writhing, almost human, forms in the sky increases; and the small yellow sphere of the sun itself appears on the horizon. The next watercolor shows the setting sun low in the sky, with its light reflected in the wake of the ship — which steams directly away from the sun and thus toward the mythical East. Then, in the final watercolor in this group, we have an extraordinary coming together of ship and sun. The boat has been transformed, as in a mirage; it is now a perfect white (suggesting its magical or sacred quality), and two slender masts have replaced the belching funnels. Its bow nearly touches the huge red sphere of the sun. This is a moment of awesome calm and beauty, and we finally come face-to-face with the sun itself.

If the previous watercolor represents a culmination in coming to know the sun, the next (the twenty-second) marks a momentary shift, a point of punctuation, for here Kiefer reverts for just a moment, and for the last time, to the darkness of night and to the ship itself. We have been on a mythic journey; as in Rimbaud's *Bateau Ivre*, artist and boat are one. But suddenly, we see a real vessel. Now, using both the recto and verso sheets to make one watercolor, Kiefer gives us a close-up portrait of a great ocean liner aglow with yellow lights, which reminds us that the trip has both realistic and mythic underpinnings.

Kiefer's watercolor pages are organized according to an internal rhythm of their own. Particularly in the earlier parts, one has a sense of the book's general direction (the gradual warming of the palette as the sun is introduced), which is in turn overlaid with a series of subtler sub-themes, each with its own ebb and flow. Thus the first half-dozen sheets explore the northern locale; the next five follow the ship in its quest up icy rivers; the following group of six studies the otherworldly colors of icebergs, sea, and mist, and the next group of four — just discussed — examine the sun itself. Then there is the nocturnal view of the ship. With it, Kiefer reminds us again that this is not a literal travel story, for the ship can change its appearance at any time, just as all of nature's forms can.

This is the last we see of the boat — a masculine, phallic symbol representing the protagonist, whom we have followed on his long journeys searching and exploring the promising yet forbidding waters of the Far North. Now the book builds to a final, climactic transition with a series of five studies of sea and sky. Echoing an earlier theme, the skies become increasingly dramatic and suggestive of human form. On one page, an inky blue-black apparition in the sky looks something like a female figure, while a stain at the bottom — apparently an accident — suggests a flowering of sexual forms. In the following drawing, above a low, red horizon, there is a large central blotted area,

either a huge thundercloud or perhaps a seated figure taking shape. Then in the next, a further evolution seems imminent. A low horizon is blurred and hardly distinguishable; the sky above is now full of pinks and pale oranges with a small rose sun; there is ferment in the upper section; again the eye strains to see a female form.

Kiefer has led us to the brink of his ultimate transition. In the subsequent three watercolors, he marks the thematic center of his narrative. The first of these (his twenty-eighth sheet) is astonishing if we have not comprehended the earlier, still-incomplete emanations that we have seen in the sky, for now a colossal temptress dramatically materializes from the delicate pinks and yellows in the sky. The sun becomes her mouth. Dressed in a low-cut gown with a slit in front, with red lips and fair, golden hair, this apparition stands like a night club singer on stage, exuding an aura of seduction. She represents sexuality incarnate, risen from the waters of the unconscious, formed from the fiery clouds of sunset. She is Aphrodite, born from the ocean's foam, which still clings to her legs. She is the sea itself, "our great sweet mother" as Joyce called her in *Ulysses*. She is Eos bringing rosy-fingered dawn; Ushas, ·daughter of the sun, lady of light; Goethe's "Eternal Feminine"; Marilyn; Brunhilde.

In the second watercolor of this trio, the woman is naked; kneeling, she fills the sky, having taken on the colors of the sun, which sets at her feet. Then, in the third, she turns to face us, her knees now astride the sea, remnants of her drapery flowing like a glacier to the small icebergs below, while a stormy sky rages overhead. With this ephochal transition, Kiefer turns his attention to the second half of his book, the "erotic in the Far East," with its thirty-five watercolors exploring the female nude. The next transitional work shows her naked body floating in the sky, with a sunset over a low horizon suggested below; here, the goddess descends and becomes human. In subsequent studies, all references to nature — to land, sea, or sky — are

removed: from now on, one has only the female form drawn with great speed on the paper. What follows is an erotic ballet of great beauty. The nude lies on her back, a leg raised like a dancer's, executed with browns and raspberry reds, her form textured with stains and blots. She arches her back; reds articulate her nipples, lips, and mouth. Her legs are spread, her hips wide and inviting. Another half-dozen studies show her on her knees, her head and feet cut off now, with blotted, flowerlike red forms — like the shapes seen in earlier skies — marking her gluteal region and genitalia. Her sexual parts are stained with dark colors; her body changes in tone to mauve and tan; she reaches back invitingly. In the following group her form becomes more abstracted; she lies on her back now, reds running from her mouth through her body. Then the pace picks up, as Kiefer speeds his ever-quickening brushwork. Pinks increase. In some cases, one sees only a few brush strokes, a mere suggestion of form. The figure changes poses from one drawing to the next; purples are used with greater intensity. Suddenly, she stands, her great hips flung out, with two burn holes from Kiefer's cigar in her thigh. On the next page, she stands again, executed in pale grays and mauves, with pubic hair made from cigar ash, the artist using the accidental with perfect ease. Two final, horizontal studies follow — both abstract, both strong. Then, as one had become ready for the woman to go on forever, she fades from sight. But the dance continues, unabated, in the mind's eye of the viewer, and of the artist.

Kiefer's work is rarely discussed in terms of style, partly because the content and iconography of his paintings cry out so strongly for attention, and partly because his style is so diffuse and difficult to analyze. There are intriguing formal parallels between his paintings and the works of a wide variety of painters and sculptors of the twentieth century, including Duchamp, Johns, Pollock, and Beuys, among others, but on the whole it is far harder to place Kiefer stylistically than intellectually. However, this

book — in keeping with its personal, self-revelatory nature — suggests some of his stylistic roots very clearly. Thus the landscape watercolors that appear early in *Erotik* recall the paintings of the great German Romantic painter Caspar David Friedrich with their evocative, empty landscapes. In these works, Kiefer shows his sympathy with essential Romantic attitudes regarding the magnificence of nature and the smallness of man, or what C. G. Carus spoke of as "the oneness in the infinity of the universe." However, while Friedrich and his generation held pantheistic attitudes toward nature and sought the divine in everything, Kiefer, their modern descendant, subscribes more to theories of emanationism as expressed in the Cabbalistic literature of Jewish mysticism, as the writer Doreet Levitte-Harten has suggested.

Closer to the present, there is also a strong connection between Kiefer's approach to the watercolor medium and that of Emil Nolde. Kiefer shares with the earlier master a mythological and animist view of things, and their watercolors at times are remarkably similar. Nolde relied very much on intuition and chance when making his watercolors; he liked to let each one simply develop on its own, going where the materials suggested. Nolde's colors are sometimes cool, but more often they are smoldering and emotionally expressive. He frequently used a soft Japan paper, which produces the same kind of deeply blurred, blotted effect that Kiefer achieves in the sketchbook with its absorbent paper. One thinks of Nolde as a master of intensely wet blues and yellows, applied quickly and directly onto the support; his interest in moody seascapes, frequently including one lonely boat, also prefigures Kiefer's work.

Kiefer's nudes also bring to mind a variety of associations. They recall the erotic drawings of female nudes made by Gustav Klimt and Egon Schiele, though Klimt's figures are more languid and self-involved than Kiefer's, while Schiele's have a more confrontational, demonic quality. A

closer comparison can be made with the late drawings of the sculptor Auguste Rodin, with whose work Kiefer became familiar as a student. Rodin drew very quickly and freely, and his women float against blank pages, taking one pose and then another, much as Kiefer's do. His female nudes fill the page, often with the hair or feet cut off, and they are rapidly executed in pale, transparent washes, as Kiefer's are. While Rodin drew his figures first in pencil (often making the whole drawing without looking down at his page) and then filled them in with watercolor, Kiefer uses no pencil at all; he simply draws the figure with his wet brush. Interestingly, the two series of Rodin's nude drawings that resemble Kiefer's most closely are "The Rising Sun" and "The Setting Sun," executed between 1900 and 1905. Several of Rodin's "Setting Sun" drawings depict a nude woman on her knees, bending over at the waist so that her head and arms touch the ground — one of a number of dancelike poses in his work that are reminiscent of the figures in Kiefer's book.

The work of Joseph Beuys, with which Kiefer was intimately familiar, also played an important role for him. Beuys' most productive period in terms of drawing was the 1950s. During these years he made a great many studies of nude female forms. These relate strongly in certain ways to Kiefer's drawings, as they were typically executed in brown wash applied quickly to small sheets of white paper. Like Kiefer's work, form is here flattened and abstracted, with a frequent omission of the head or feet. However, while Beuys's women can suggest sexual connotations, they do so in a fragmented, two-dimensional way. Beuys' drawings never suggest real flesh and blood, and, though he often emphasizes breasts or sexual organs, his nudes are rarely erotic or celebratory in the way that Kiefer's are.

Kiefer's own earlier work also seems to have served him. His interest in archetypal women as well as in bookmaking can be traced back to his student days. In 1969 he made an interesting small book of collages, which he entitled *Die Frauen* ("The Women"). On its loosely bound pages he glued small cutouts taken from popular magazines: the images are so tiny that it is difficult to make out what they represent, though in time one realizes that one is seeing a detail of a nostril, an eye, an edge of a piece of jewelry, a navel, and so on. Like the larger books, it has a flow and rhythm of its own, one that depends on both scale (the collaged pieces begin about one inch square in size, then are gradually reduced to mere dots, and then they grow larger again — an early example of a careful "transition") and on material — for while most of the pages use photographic cutouts, several startlingly employ real hair, plastics, and the like. Many of the pages include only the collage, but a number are inscribed with the names of various mythic princesses and goddesses of the day, including Sharon Tate (represented by a piece of skin), Princess Grace (her hairline and an earring), Jacqueline Kennedy Onassis (a tear), and Gina Lollobrigida (a very small detail of her face). In certain aspects, the book gives evidence of both Minimalist and Pop sensibilities, but it also shows Kiefer at a young age, having already formed many of the interests which would lead to *Erotik im Fernen Osten*.

Several critics have correctly noted the materiality of Kiefer's paintings — their physical literalness and their attention to the materials with which they are made. This is most apparent in the large, layered paintings, in which sand, lead, and other such elements cover and transform large-scale photographs, which in turn cover canvas and stretcher, but it is equally evident in Kiefer's watercolors. In this materiality Kiefer follows the lead of his teacher Joseph Beuys, a superb if unconventional draftsman who was best known for his "actions" and for the sculptural objects stemming from those actions. As Beuys said, "It is the transformation of substance that is my concern in art, rather than the traditional aesthetic understanding of beautiful appearances."[2]

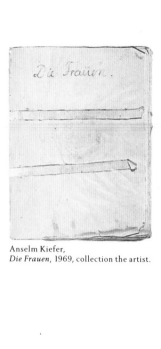

Anselm Kiefer,
Die Frauen, 1969, collection the artist.

110–111

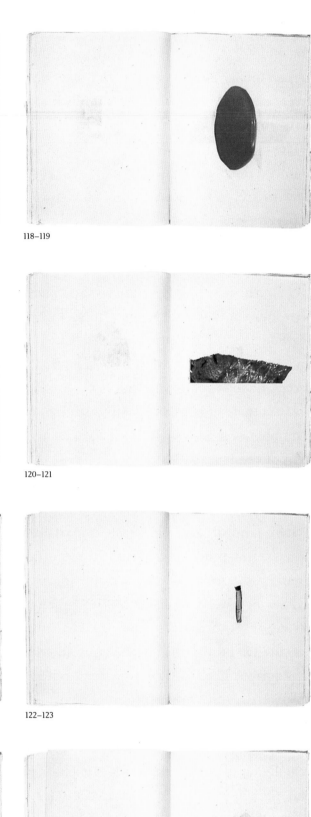

118–119

112–113

120–121

114–115

122–123

116–117

124–125

126–127

128–129

130–131

132–133

134–135

136–137

138–139

140–141

In *Erotik im Fernen Osten*, as in so many of his works, Kiefer's approach is full of risks as he orchestrates a constant dialogue between materiality and elegance, between the ideational and the beautiful. His hand is as gifted as his mind, and the creation of decorative drawings, watercolors, and paintings comes easily to him: but he resists this temptation. His practice is to include the aesthetically beautiful in the object — as a lure, in a sense, for the viewer — then to layer it with idea, meaning, reference, and the psychic charge that gives it significance. Truth for him, as for many German artists before him, encompasses far more than what we think of as beauty; disagreeing with the nineteenth-century Romantic poet John Keats, he sees beauty as merely a matter of appearances, and he believes that truth for the artist is a far more complicated matter.

In Kiefer's watercolors one can clearly observe the struggle between truth and beauty. He has been at ease with this medium since 1970 or before, though he employs it sparingly, with a keen sense of the dangers involved. In one watercolor of 1975, *Kranke Kunst*, he depicts a scenic Norwegian landscape and over it paints what at first appear to be a number of pink flower blossoms, but that, on closer examination, turn out to be abscesses running with pus; then, to make his point completely clear, he writes at the top of the sheet "*Kranke Kunst*" (meaning "sick art"), a reference, among other things, to the Nazi attack on "degenerate" modern art in 1937.[3] Kiefer typically superimposes one level of meaning on another in this way, in both his watercolors and paintings.

Erotik im Fernen Osten is handled differently, but to the same end. The watercolors here are simple and direct; they contain no written signs or text, and no second level of imagery. Yet Kiefer accomplishes his aim — offering us and then withdrawing the beautiful object — in other ways. For example, the paper he has used is pulpy and low-quality, providing the book with a sense of its own mortality. The binding is poor, and the paper thin and

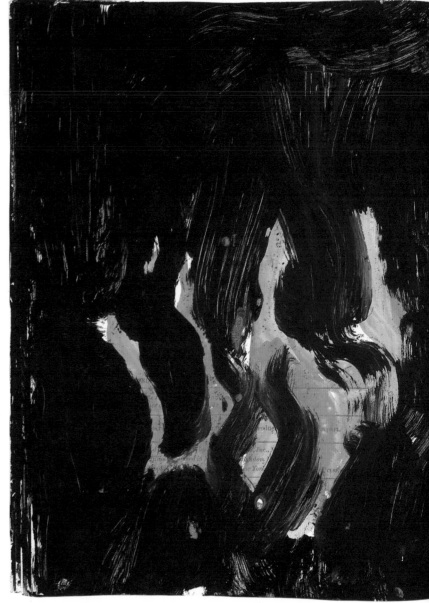

Anselm Kiefer, *Brunhilde and Her Fate*, 1977, collection the artist, pages 10-11.

fragile, so that each person who handles it hastens its end, just as when one touches a delicate flower. Moreover, the artist has painted the watercolors on the front and back of many pages, so it is impossible to take the book apart in order to display it. In addition, Kiefer has given the book multiple levels of meaning that slowly become apparent through his sequential treatment of the watercolors: to see just one page out of context is to drain the meaning from it.

But this technique is consistent with his philosophy, for he made the book more by instinct than by plan; it evolved in the direction he desired, but without a firm design made

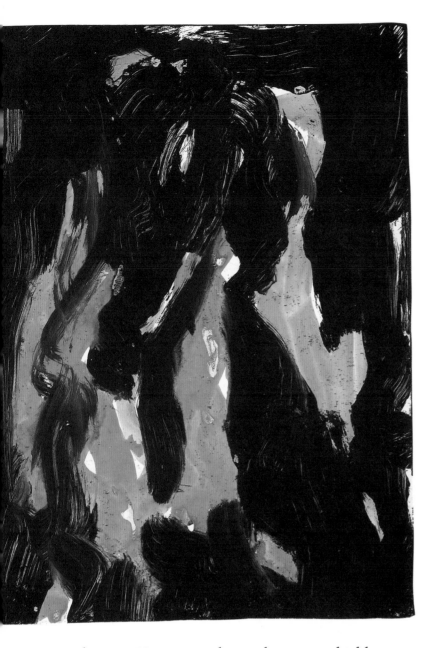

Thus a sequence of images that starts coolly, as an exploration of rivers and icebergs, has become a passionate exploration of sensuality. But apart from the technical virtuosity through which the artist displays his mastery of a medium for which he is little known, is there a further meaning in these images? Does the book represent an anomaly, a momentary escape into pure "art," or does it connect with the mainstream of Kiefer's work? Indeed, further study proves that it is no mere formal exercise, but an expression of some of the artist's most profound concerns.

Kiefer fears modern culture, with its emphasis on rationality and progress, and warns against intellectual as opposed to visceral understanding. Unlike Beuys, however, Kiefer does not play the role of shaman, but the two artists share the conviction that art can play an important role in showing us the way to emerge "from the current crisis brought about as a result of positivist, materialist, and mechanistic thinking in the west."[4] Beuys' work "concerns the most fundamental relationship of people to myth and magic, a relationship that has been obscured by modern science and technology."[5] Kiefer believes that our vision of the world must be extended in order to encompass all the invisible energies with which we have lost contact; a major theme for him is repairing what a Jungian theorist has called "the collective psychic rift" that has occurred in the twentieth century, when "civilization was removing man further and further from his instinctual foundations, so that a gulf opened between nature and mind, between unconscious and consciousness."[6]

Kiefer chooses his themes with care, as Doreet LeVitte-Harten has perceptively noted. In the myths of Gilgamesh, Icarus, and Siegfried, all three of which Kiefer uses frequently in his work, LeVitte-Harten suggests that "before being moral lessons, they constitute an opinion about the break between man and nature, about the values which were lost in the transition from 'society in nature' to an urban society."[7] For example, in the

in advance. His watercolor technique is highly spontaneous, and he leaves a great deal to chance: he starts with a conceptual notion of what he is aiming for, but no preliminary sketches, in fact no use of pencil at all. The sheet is heavily wetted with water and pigment, and, after some drying has begun, he goes where the wet colors want, working quickly, blotting, drying, wetting again. As the pages are already bound, there can be no editing; every touch of the artist, every accident, is recorded. This technique would be extraordinarily risky for another artist: somehow, with Kiefer, water and color mesh easily with chance and skill, and the result is a book that seems an effortless, organic whole.

Gilgamesh epic, Enkidu falls, seduced by a courtesan, and thus loses his privilege of living with the creatures of field and forest — a typical example of the fall of natural man.

Kiefer has read Antonin Artaud, the twentieth-century French writer who was so interested in the primitive religions whose cosmologies explain the creation of the world in terms of masculine and feminine principles.[8] Like Artaud, Kiefer himself is inclined to see things in terms of masculine and feminine forces, of yin and yang, the traditional Chinese forces representing the competing, complementary powers of the universe. Artaud, like such earlier French Symbolists as Rimbaud and Baudelaire, believed that the artist/writer had a unique ability to explain metaphysical realities; he saw man as capable of coming in touch with ancient animistic myths and his own relation to the cosmos through poetry or art. The lure of pagan religions for Artaud (whose *Heliogabale* is the subject of a Kiefer watercolor of 1974) lay in their emphasis on myth, ritual, and sexuality, key forces that, he believed, are repressed in modern society. Like his colleague Jules Breton, Artaud believed that surrealistic and "primitive" thought shared the aim to suppress the hegemony of consciousness and to release revelatory emotions. Thus the sexuality in Kiefer's book may be seen as standing for all of man's natural instincts, as representing his connection with revelatory life forces and the cosmos, and the triumph of the unconscious over the rational.

Kiefer's watercolor book, on one important level, reconnects us with the emotional aspects of what is for most primitive cultures an archetypal myth, that of the rising of the sun. Every primitive society is deeply concerned with the eternal cycles of night and day, departure and return, winter and summer, death and birth. Almost universally the sun is seen as the supreme cosmic power, the symbol of God and of goodness, the universal father, and of life itself. Inevitably connected to the renewal of the sun are rebirth and fertility, especially when the sun is connected

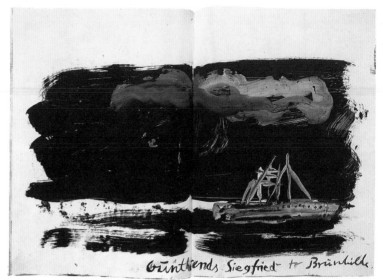

Brunhilde and Her Fate, 46–47

to the sea, which is typically symbolic of the Great Mother — the universal womb, the waters of fertility and refreshment, the deepest unconscious. Water and fire are the two conflicting elements that ultimately and inevitably penetrate each other and unite. In Kiefer's version of the myth, a long search is made through cold waters; the sun is reborn, then merges into the sea; a female apparition appears, then becomes human and desirable. In the early watercolors we feel the chill of the waters and the promise of rebirth suggested by the sky; we share in the wonder of the sunrise, and then in the pleasures of uninhibited sexuality.

The first part of the book records a journey, and one recalls how many of Kiefer's works have to do with travels. This is a favorite theme, one that echoes the arduous voyages of real and mythic heroes in many cultures. For Kiefer, the journey is always a metaphor for intellectual, spiritual, physical, and moral change and transformation. One thinks of Odysseus' trip to Hades, of his return to Penelope in his quest for wholeness; or of Faust's visit to the mysterious "mothers." The people of Israel wandered in exile for forty years (and Kiefer has made numerous works on the Exodus theme); Christ made his last fateful, necessary trip to Jerusalem. James Joyce's Bloom cannot actually wander, so his imagination ranges far and wide,

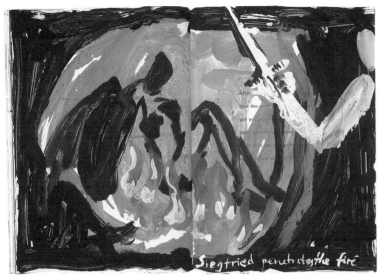

Siegfried penetrates the fire

58-59

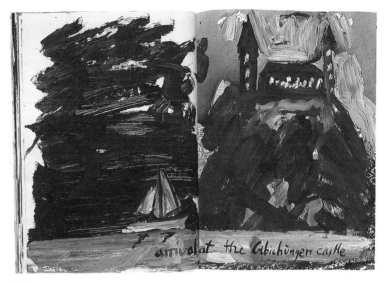

arrival at the Gibichungen castle

80-81

and he begins to fantasize about being "somewhere in the East . . . turbaned faces going by"; the few books Bloom owns include *Voyages in China*, *Three Trips to Madagascar*, and *In the Track of the Sun*. In every culture and in our dreams, the hero travels to unfamiliar places, meets danger, and wins the opportunity for growth or rebirth. The hero always seeks the wandering sun, according to Jung. Several of Kiefer's large books depict the Rhine River, the source and symbol of Germany's essence: in these volumes, one travels beside the river from the time it rises in the mountains until it becomes broad and strong. The river gives promise of going on and on forever, just as the woman does in the watercolor book — until it fades, then disappears, as she does.

Around the time he made the watercolor book, Kiefer was much involved with the Nordic legend of the Nibelungen. He is familiar with this story in its many manifestations, and in his works one finds him making use of the Eddas and other early sources, along with Wagner's *Ring of the Nibelung*.[9] While varying considerably in some details, the essential story describes the struggle between creation and destruction, and the conflict between the lust for power and wealth and the search for love.

In the Wagnerian version the gold lying deep in the Rhine River, guarded by the Rhine maidens, represents the wealth and power that both men and gods seek; even Wotan, king of the gods, lusts for Alberich's ring, made from the gold, though it is cursed and brings destruction to those who wear it. The Valkyrie Brunhilde has been cast into a deep sleep, where she is protected by a circle of fire against all but the very bravest of men. Siegfried, the hero, slays the dragon who guards the ring, and takes it. A child of nature who has never seen a woman, he understands the wild bird's song, which leads him to Brunhilde's rock. After defeating Wotan in battle, he pierces the flames and awakens Brunhilde. Leaving behind his love, he goes to pursue his destiny. He comes to the castle of Gunther, where Hagen (the king's half-brother) is plotting to take the ring. The unsuspecting Siegfried is given a magic potion that makes him forget Brunhilde; he then falls in love with Gunther's sister, Gutrune. Still drugged, he agrees to go to Brunhilde disguised as Gunther to take her as Gunther's bride. After he goes through the fire again and claims her for Gunther, he makes plans to marry Gutrune. Brunhilde, realizing she has been tricked, is enraged and plans revenge on Siegfried. The Rhine maidens urge Siegfried to give back the ring, warning of its dangers, but he refuses. Hagen — urged on by Brunhilde — stabs Siegfried, who in his dying moments regains his memory and proclaims his love for Brunhilde. Brunhilde then real-

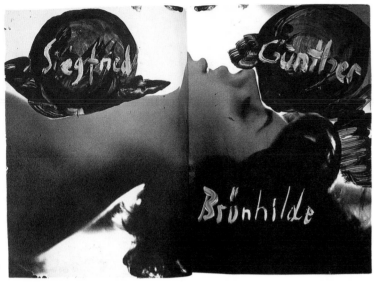

Brunhilde and Her Fate, 102-103

izes that Siegfried is innocent; taking the ring to give back to the Rhine maidens, she rides her horse, Grane, into Siegfried's burning funeral pyre, proclaiming their love. Flames then engulf Valhalla, palace of the gods, and the gods are thus destroyed; at the end, the Rhine rises and floods the scene.

A knowledge of the Nibelungen myth is necessary if we are to understand Kiefer's art — including this book — and the negative critical reception that Kiefer has often faced in Germany. The fact is that the use of myths, and particularly this one, makes postwar Germans nervous because the Siegfried legend (especially in its Wagnerian form as outlined above) is well remembered as a favorite of the Nazis. However, it was far from their invention, for its roots lie deep in German history, and it has been called "the German *Iliad*." The myth enjoyed a great revival in the nineteenth century and remained very popular through the Second World War.[10]

After the war, Germany reacted strongly against almost everything that had been associated with the Nazis. Beginning in 1945, the year of Kiefer's birth, German students no longer studied northern mythology and folklore, and especially such stories as the Nibelungen. Indeed, since then, this myth has been largely avoided: its primary use has been for satirical purposes, and the values that Siegfried used to stand for, such as loyalty and heroism, have been parodied as well. Robert T. Odenman's 1975 satire on heroic German poetry, *Everyone's Afraid of Uncle Hagen*, is a typical example. Joseph Beuys felt fortunate to have had a teacher who instilled in him a love of Icelandic sagas and Scandinavian history, and Kiefer is one of the few members of his generation who believes these myths are inevitably part of his and our multiple consciousness. For Kiefer, the Nibelungen saga is simply *there*, demanding to be confronted, necessarily relevant.

In retrospect, it seems odd that the Nibelungen legend,

and especially Wagner's operatic version, was so popular with the Third Reich. For as Martin van Amerongen points out, "The moral of the Nazis runs counter to the moral of the Ring, and the latter is quite unambiguous: avarice and thirst for power lead to ruin."[11] To contemporary eyes, the Nibelungen myth seems a perfect cautionary tale for the Nazis, rather than an apologia. Siegfried is a heroic figure, but—as Kiefer explains—one whose doom is sealed when he loses touch with nature in failing to listen to the Rhine maidens' warnings to return the ring. However, he is limited, being vulnerable to the intrigues of Hagen and the allure of Gutrune, and (like modern man) he is easily led astray. It is Brunhilde alone who sees the truth, experiences love and compassion, and turns her back on greed and power by returning the ring to the Rhine maidens. The end of Wagner's *Ring* (like that of the Third Reich) brings complete disaster: the world of gods and men is wholly destroyed. This pessimistic conclusion accords with Schopenhauer's view of tragedy, and recalls a similarly desolate conclusion in the American Romantic painter Thomas Cole's *Voyage of Empire*: only through total destruction of corrupt civilization and a return to the original state of nature can there be any continuity or hope.

Kiefer himself became concerned with the Nibelungen during the mid-1970s, and he continues to make works devoted to the theme. Kiefer probes and reworks a few potent themes which he finds both personally moving and morally relevant for today's world. Brunhilde's death fascinates him: in a large painted-over woodcut, he shows her on Grane, riding into the funeral pyre; in a watercolor of 1976, her naked, charred body is shrouded in black smoke, with embers burning at her feet and floating up around her; a painting of the same year (called *Brunhildes Tod*) shows only the black, burning logs—smoldering after the immolation of Siegfried and Brunhilde—against a desolate but somehow beautiful gray background. We are reminded that, according to the legend, only she was both courageous and wise.

Perhaps the central episode in the legend for Kiefer is denoted by three words that he uses over and over again in works in all media: "*Siegfried vergisst Brunhilde.*" In a gloomy and otherworldly drawing of the mid-1970s (made with black paint over a photograph), Kiefer depicts a strange field of mushrooms—known for their poisons—and a bottle that carried the magic potion; in this lament, one sees the instruments of the crime, the cause of the disaster. Two major paintings of 1975 depict ploughed fields in winter; in one of the ruts, Kiefer (or Siegfried, or God) has written the lament "*Siegfried vergisst Brunhilde*"; the words stretch out toward the horizon, growing smaller in the distance but echoing again and again: Siegfried forgets Brunhilde. The sky and the land look gray and bleak, reflecting their sorrow and telling of the artist's feelings, as Kiefer's landscapes always do. Kiefer always uses the present tense: the problem of forgetting is not studied as history seen from afar, but is rather presented as our problem. Kiefer looks into himself, he looks into the soul of Germany, he considers mankind, and the words and images come again and again—and always Siegfried forgets.

This episode, which looms so large for the artist, is a factor in Wagner's operas, though interestingly it does not appear in the German medieval poem the *Nibelungenlied*. In this case Kiefer follows the Wagnerian version, in which Siegfried's loss of memory is caused by the magic potion administered by Hagen, a Machiavelli who is efficient and highly dangerous. Siegfried's forgetting has to do with his gullibility and his naiveté, weaknesses that have come about because he has lost touch with his instincts and his natural sources. To blame the loss of memory on a magic potion is to blame it on the unconscious. Siegfried falls for another woman, forgetting Brunhilde; in Jungian terms he has a "wandering anima." As the Jungian scholar Robert Donington writes, "Not having established any stable relationship with her [his anima] in psychic consciousness, he can reach no stability in his projection of her on to the

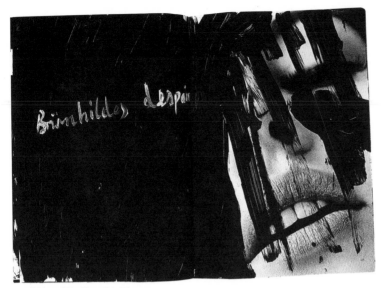

Brunhilde and Her Fate, 110-111

women he meets."[12] What Siegfried most significantly has forgotten are his roots in nature, represented by the wild bird and by his first, innocent love for Brunhilde.

In 1977, at the same time the watercolor book was being conceived, Kiefer made a small book entitled *Brunhilde and Her Fate*, which is not only important in its own right but also sheds light on the watercolor sketchbook. In his books and paintings, Kiefer often uses photographs that are almost always his own; he then frequently alters the photographic image by applying paint or other materials. However in *Brunhilde and Her Fate* he took a book (*The Mirror of Venus*, by Wingate Paine, with words by Françoise Sagan and Federico Fellini), and then altered it in remarkable ways to suit his own purposes. *The Mirror of Venus* is a commercial product. Intellectually undemanding, it includes arty photographs of nude models not unlike contemporary *Playboy* images, as well as a text by two well-known pop-culture figures. Kiefer considered the book to have no intrinsic value; he used it for the same reason he uses other difficult materials — to destroy it and transform it. He succeeded by appropriating Paine's book and turning it into his own work of art, and also showed himself to be more comfortable with popular art and closer in attitude to Andy Warhol and Tom Wesselmann at this formative point in his development than one might have expected.

Brunhilde and Her Fate begins with Siegfried looking for Brunhilde: Kiefer's opening picture is painted a dense black, which completely covers the original book's page and is relieved only by touches of white, reminiscent of snowflakes or stars. There is a feeling of infinity and longing. We then see Brunhilde's face surrounded by flames on several pages, then "Siegfried on the Way," again signified by a page of loose brushwork. On some pages Kiefer suggests the mood and the continuity of Siegfried's arduous journey; on others he lets part of the underlying photograph show through, and with extraordinary facility and

editing he turns Paine's images into a contemporary and somewhat Pop, but also a powerful and profound, version of the Nibelungen saga. He uses mainly black paint, with occasional whites and reds. About half the images carry Kiefer's writing, and, as in the subtitle of the watercolor book, the language he uses is English. Brunhilde becomes a pretty, long-legged American model with dark hair; and, atypically, Kiefer draws occasional figures for Siegfried and the other major characters. After Brunhilde and Siegfried first come together, she is seen alone, smiling, with a white spermlike rain falling. When Siegfried leaves ("Siegfried's Trip on the Rhine"), he is represented by a boat that looks like a warship. Kiefer devotes a page to "Siegfried Forgets Brunhilde" (almost all black), but there is no indication of the magic potion or how it was administered. Siegfried marries Gutrune (who is seductive and naked); then Gunther sends Siegfried back to Brunhilde, and the ship now looks more like a sailboat. In several images, we see Brunhilde's face with blood on her mouth, covered with flames and blackness. Siegfried penetrates the fire and takes Brunhilde for the second time, but there is no mention of his being a stand-in for Gunther and no sign of the ring or the gold.

The tale here has become a simplified one of voyages and of lust and sexuality. Brunhilde's body is seen with black sperm around it; we see just her feet and legs raised high, the underlying photograph using a pose much like the ones Kiefer employs for the woman in *Erotik im Fernen Osten*. Siegfried brings Brunhilde to Gunther; their small toy boat is shown arriving at the Gibichungen castle, and there follow two pictures of "The Wedding Banquet" — a young woman drinks champagne and the page is painted over in bright yellows, representing a complete change of mood and color. In "Gunther Cannot Subjugate Brunhilde," we see a woman in a bathroom wearing stockings and a boa around her neck, then posing coyly in bed. In places such as this, where the original photographic images are seen largely intact, we recognize their cheap con-

temporaneity, and the artist seems to imply ironically that Siegfried and Brunhilde are Everyman and Everywoman, and that we live out myths in pathos and humor in our everyday lives. Siegfried helps Gunther to subjugate Brunhilde, with Kiefer here portraying the three together, symbolizing their intertwining deceptions. Gutrune discovers the fraud, Hagen kills Siegfried, and the last pages — now very moving — are devoted to dark, obscured images of Brunhilde's face, full of despair and agony.

In its small scale, its humor, its involvement with the erotic, and, most important, in its theme of eternal searching, *Brunhilde and Her Fate* is closely related to *Erotik im Fernen Osten*, made in the same year. In these two works, Kiefer's approach is intimate and direct, as he deals with questions of taste and vulgarity while still achieving both profundity and beauty. These works are no less challenging and no less complex than his massive paintings, which he began to make at about this time. Moreover, both books deal with the Nibelungen saga, *Brunhilde and Her Fate* in the form of a modern narrative, *Erotik im Fernen Osten* as abstraction, as dream.

In his essay of 1848, *The Nibelungen: World History Out of Saga*, Richard Wagner "traces the figure of Siegfried back to its mythical origin in the light and sun god, his slaying of the dragon symbolizing the triumph of day over night."[13] Siegfried in this sense is the German Hercules, and both share many attributes of the sun-hero. In Wagner's *Ring*, the cycle is completed, for the dragon's successors murder Siegfried, just as night kills day. In a parallel development, *Erotik* metaphorically traces Siegfried's journey to find himself, first in the form of the sun, then in the form of the woman — or, as Jung would say, his anima. Kiefer is a reader of Jung; there can be no doubt that Jungian theory helps us to understand the book's mythic import — a quality that we surely feel when we go through it page by page. Jung's "Song of the Moth," a lengthy interpretation of a woman's dream about a moth

that tries to rise to the sun, outlines his view as to how primitive theories of light gradually developed into the idea of the "sun-hero" in various cultures. Analyzing the dream, Jung digs down into "the historic depths of the soul" and finds there "the youthful, beautiful, fire-encircled sun-hero" who wanders the earth, causing night to follow day. He is represented by the longing of the dreamer, the passionate (and erotic) longing that can lead to love or destruction. As Jung writes: "The longing is the same; the object changes. Nature is beautiful only by virtue of the longing and love given her by man. . . . The dream recognizes this well when it depicts a strong and beautiful feeling by means of a representation of a beautiful landscape. Whenever one moves in the territory of the erotic it becomes altogether clear how little the object and how much the love means."[14]

The same theme and the same connections between the life of the sun and the life of man, between natural and human renewal, can be found in many cultures. Kiefer, for example, is much interested in cabalistic mysticism; the central text of the Cabala, the Zohar, dating from the twelfth century, is "replete with highly erotic imagery, for its anonymous author saw the act of human love-making as a mirror of the divine and ecstatic process of celestial creation."[15] Or, as another scholar wrote, "The Zohar sees nothing unspiritual about examining the human body, and particularly the sex act, as a paradigm of the hidden spiritual universe from which all existence draws its life."[16]

Erotik im Fernen Osten is above all a poignant statement about human beauty and about human longing. It relates to the primitive, innocent part of the Nibelungen saga when Siegfried was on his way to Brunhilde for the first time, and when he had just seen her and loved her. It represents Siegfried before his loss of innocence, before his forgetting became inevitable. Full of longing, he follows the "infinite Eastward" path, repeating the steps made by countless seekers before him. For Jung the mean-

ing of such myths is clear: "it is the longing to attain rebirth through the return to the mother's womb, that is to say, to become as immortal as the sun."[17] Rebirth of the sun means the rebirth of life; man's rebirth, through sexuality, follows inescapably.

In the Nibelungen saga, Siegfried looks on Brunhilde for the first time and mistakes her for his mother. In Kiefer's book, the viewer sees emanations in the sky growing ever more human until suddenly he perceives a huge, all-powerful female figure — an unrealistic projection, his anima. But his fantasy image may become real, with the figure evolving into a flesh-and-blood woman, a sexual partner with whom he can begin a seemingly endless erotic dance. Discovery of the woman represents a coming into balance of major polarities, the dark and the light, the complementary feminine and masculine principles. Man has the capacity to regain his connection with nature, with her invisible forces. Kiefer thus says that Siegfried need not forget. However, he can only suggest a means, but not a solution to this eternal human dilemma. *Erotik im Fernen Osten*, like many of his other works, suggests an instant in time, a fragment of the natural cycle. At the end, as Jung wrote: "The problem is not solved; all sorrow and every longing begins again from the beginning, but there is 'Promise in the Air' — the premonition of the Redeemer, of the 'Well-beloved,' of the sun-hero, who again mounts to the height of the sun and again descends to the coldness of winter, who is the light of hope from race to race, the image of the libido."[18]

■

NOTES

1. Alice Horton, *Lay of the Nibelungs*, Edward Bell, ed., with essay on the *Nibelungenlied* by Thomas Carlyle (London, 1898).

2. Joseph Beuys, as quoted in Caroline Tisdall, *Joseph Beuys* (London, 1979), p. 10.

3. See Anne Seymour, *Anselm Kiefer's Watercolors* (London, 1983).

4. Caroline Tisdall, *Joseph Beuys* (New York, 1979), p. 207.

5. Karin Berquist Lindegren, as quoted in Caroline Tisdall, *Joseph Beuys* (New York, 1979), p. 134.

6. Aniela Jaffe, "Symbolism in the Visual Arts," in Carl G. Jung, *Man and His Symbols* (Garden City, N.Y., 1964), p. 253.

7. Doreet LeVitte-Harten, "Anselm Kiefer," unpublished lecture given to the annual meeting of the Saturnian Society, 1986.

8. See Naomi Greene, p. 126 *Antonin Artaud: Poet Without Words* (New York, 1970).

9. The major versions of the legend are found in the *Nibelungenlied*, the German heroic epic poem composed in about 1200, probably by a minstrel poet in southern Germany, and based on lost poems dating from the fifth and sixth centuries and later; the *Elder* or *Poetic Edda*, a collection of traditional Scandinavian poems probably from the tenth through twelfth centuries; the *Younger* or *Prose Edda* written by the Icelandic writer Snorri Sturluson in about 1220; and the *Volsunga Saga*, written in about 1270–1275 on the basis of much earlier material.

10. The Nibelungen saga was first used for political purposes during the Napoleonic Wars, at a time of great national interest in Germany's past, and Siegfried the dragon slayer came to be thought of as a heroic figure, a German Achilles. German authors during the nineteenth century produced dozens of plays based on the story, and at mid-century there were several operas, the best known of which was Richard Wagner's four-part *Ring of the Nibelung* (1854–1874). The Nibelungen legend continued to grow in popularity during the early twentieth century, especially during the First World War, when Siegfried was increasingly taken as a symbol of German military strength and valor. Then, during the Third Reich, Siegfried came to be seen as a prototype for Nordic man and for the German race. Poems, plays, and novels all used this theme during the 1930s. During the Second World War, Siegfried stood for valor and loyalty and — with the German defeats of 1943–1945, increasingly came to represent fatalistic acceptance of disaster. See Winder McConnell, *The Nibelungenlied* (Boston, 1984).

11. Martin van Amerongen, *Wagner: A Case History* (New York, 1984), pp. 120ff.

12. Robert Donington, *Wagner's "Ring" and Its Symbols* (London, 1963), pp. 225, 230.

13. H. F. Garten, *Wagner the Dramatist* (Totowa, N.J.), p. 82.

14. See Carl G. Jung, *Psychology of the Unconscious* (New York, 1965), p. 95.

15. Edward Hoffman, *The Heavenly Ladder* (San Francisco, 1985), p. 23.

16. Herbert Weiner, *9½ Mystics: The Kabbala Today* (New York, 1969), p. 28.

17. Carl G. Jung, *Psychology of the Unconscious* (New York, 1965), p. 240.

18. *Ibid.*, p. 126.

A BOOK
BY ANSELM
KIEFER

Erotik im Fernen Osten

oder:

Transition from cool to warm

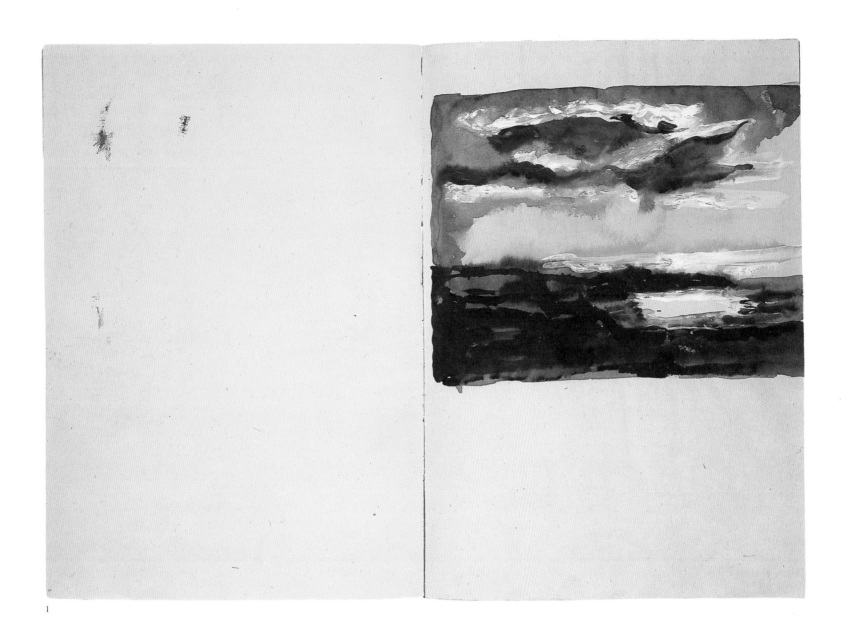

1

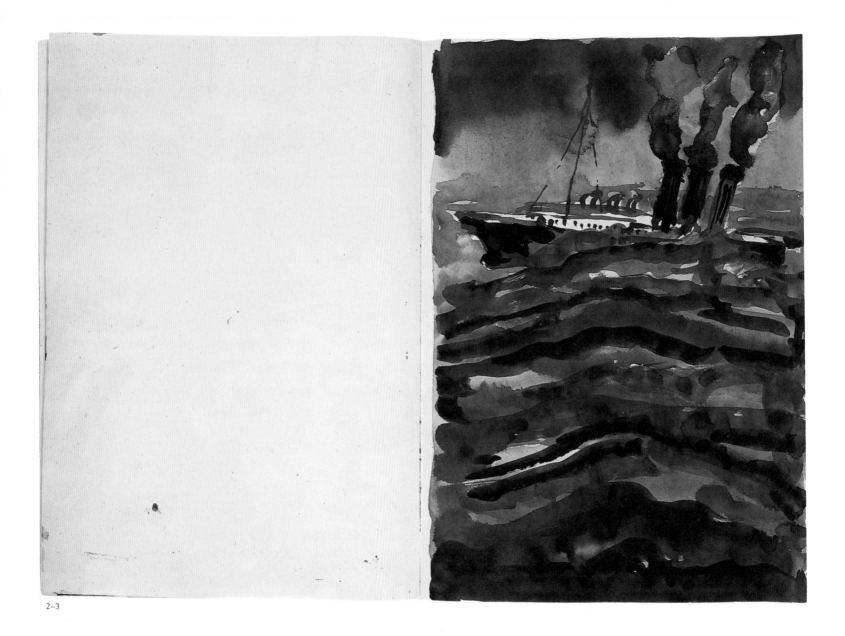

2–3

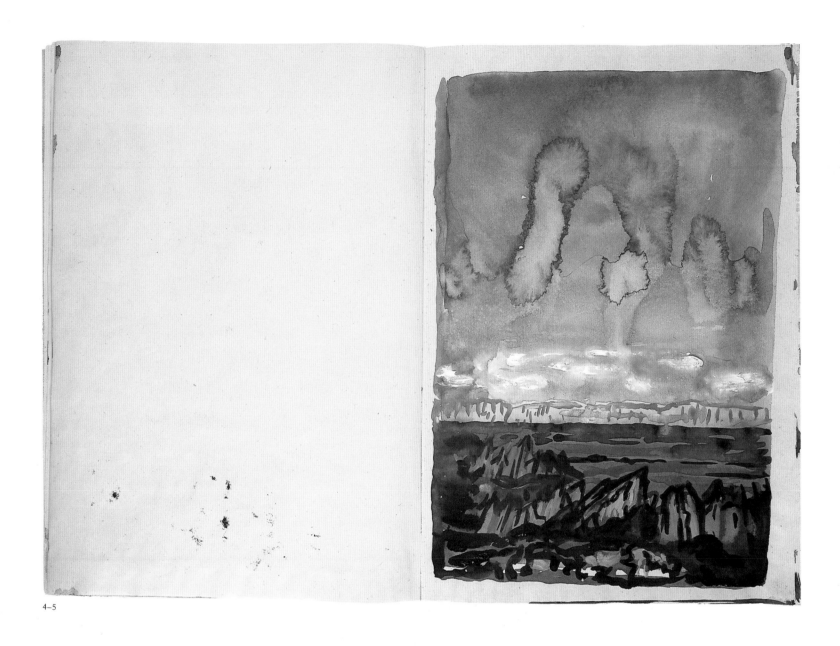

4–5

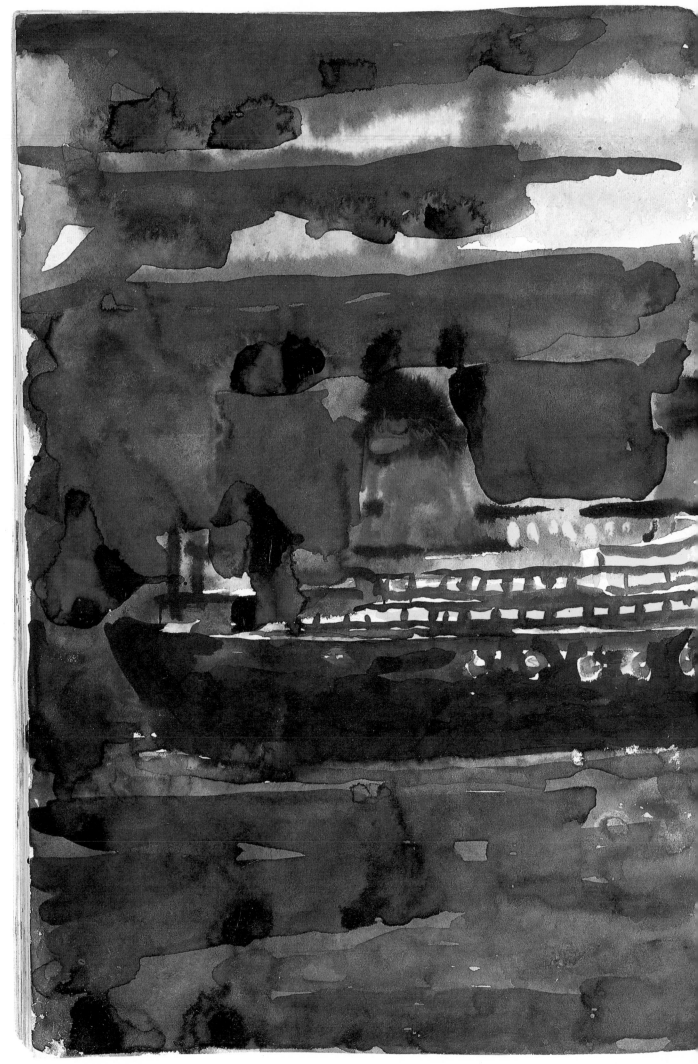

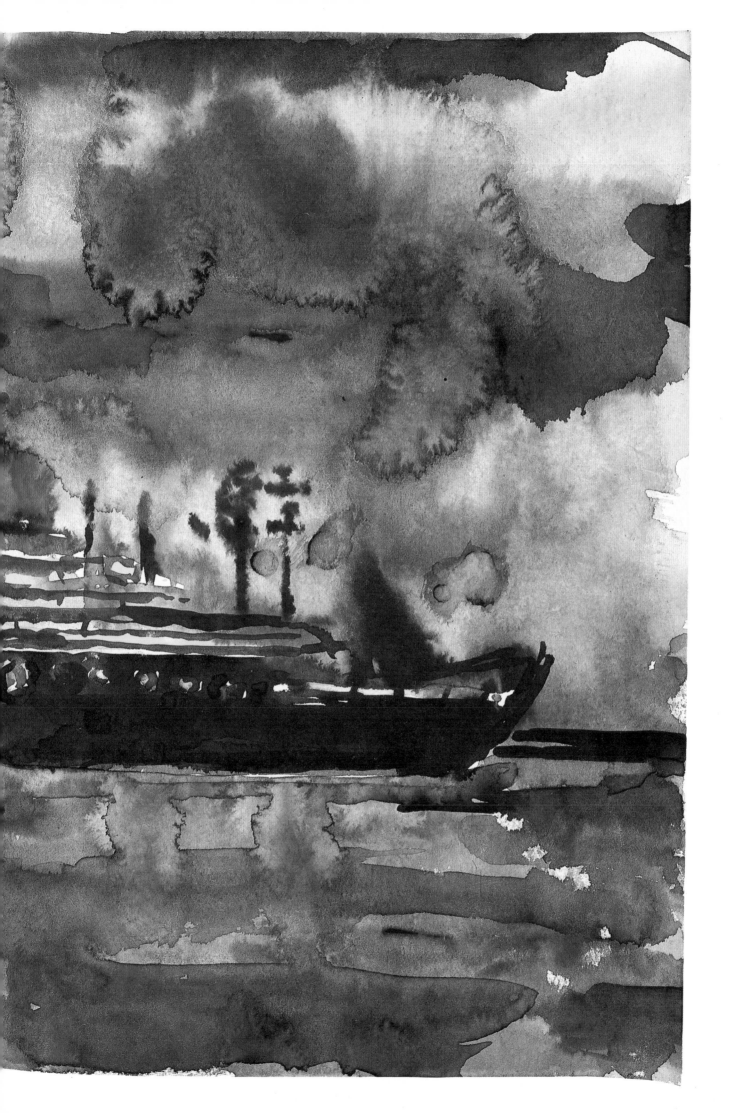

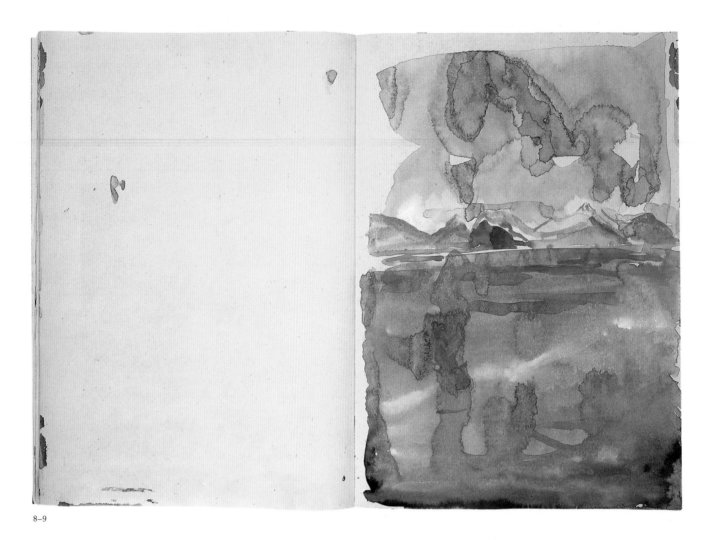

8–9

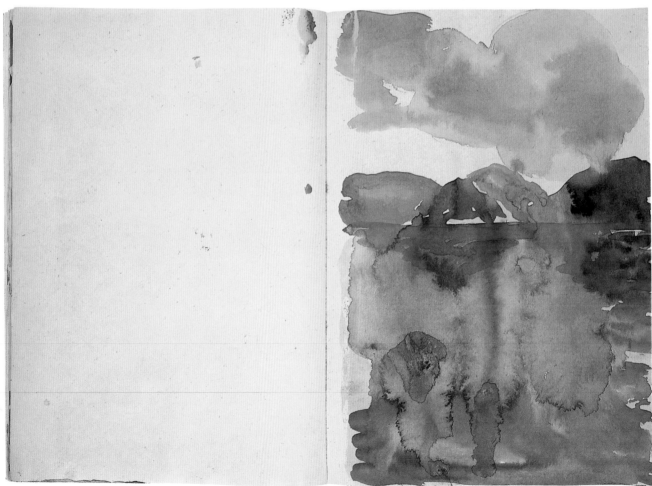

10–11

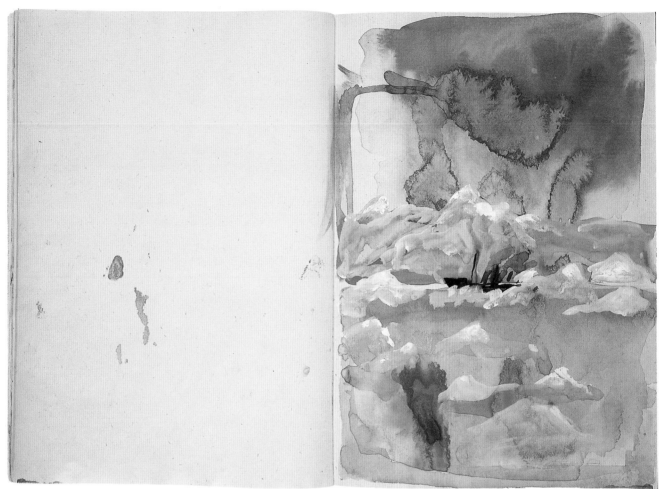

12–13

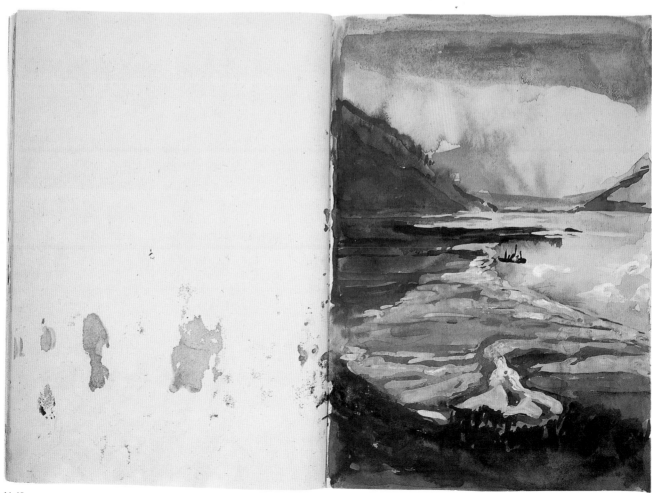

14–15

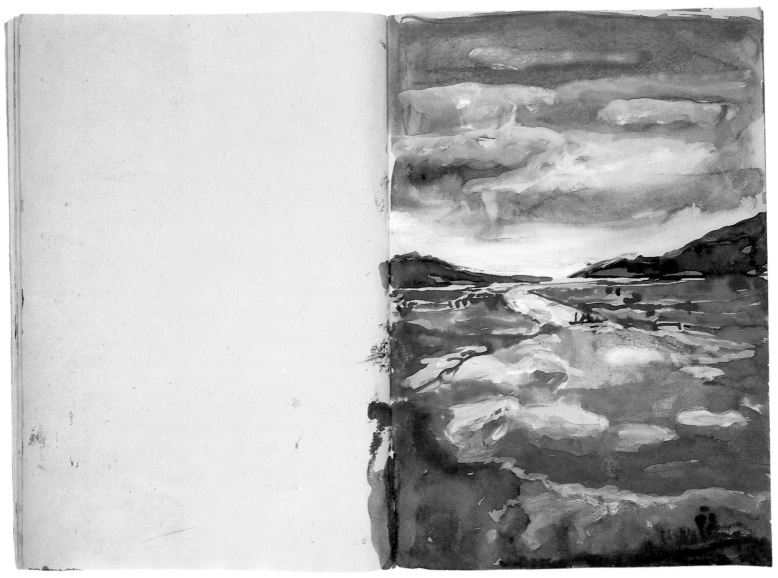

16–17

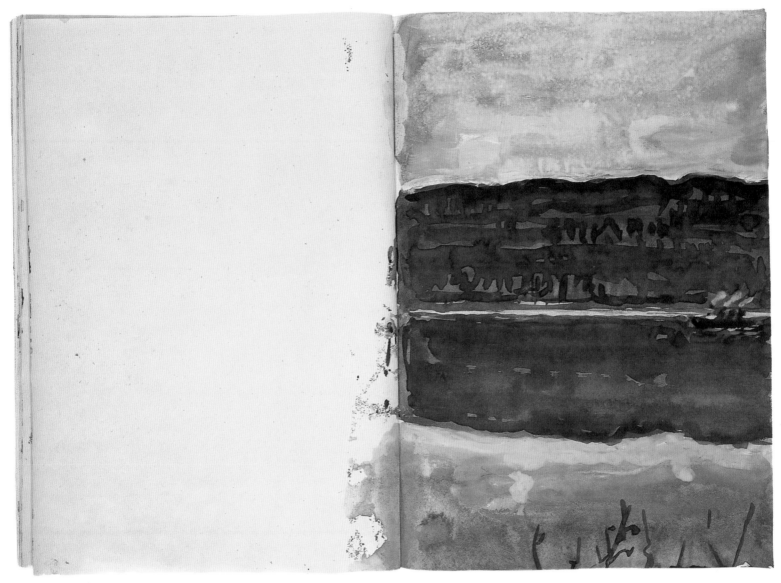

18–19

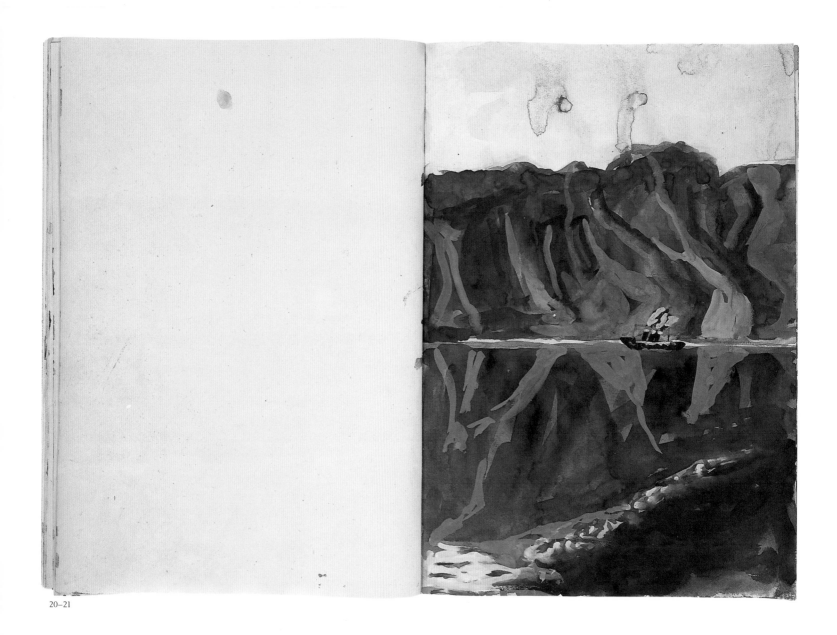

20–21

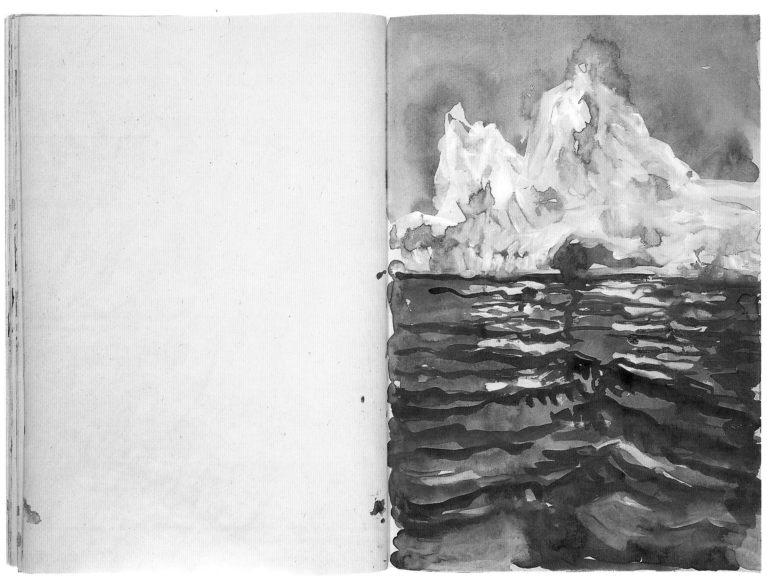

22–23

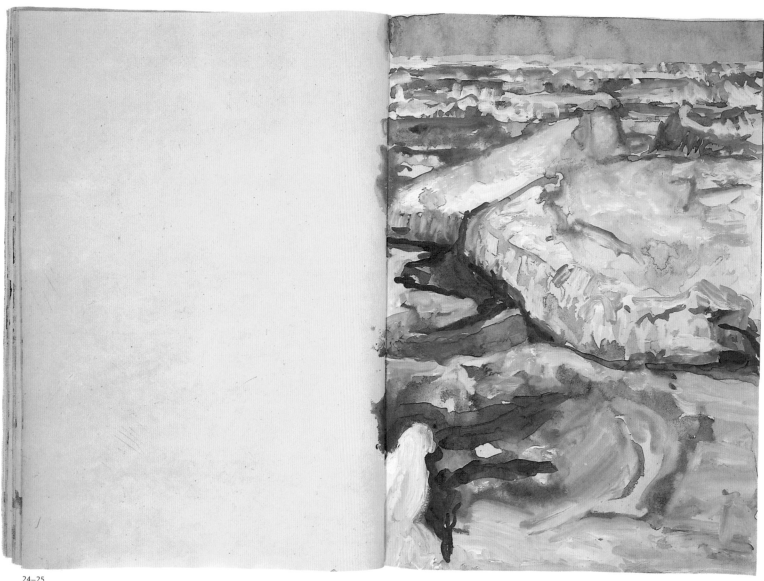

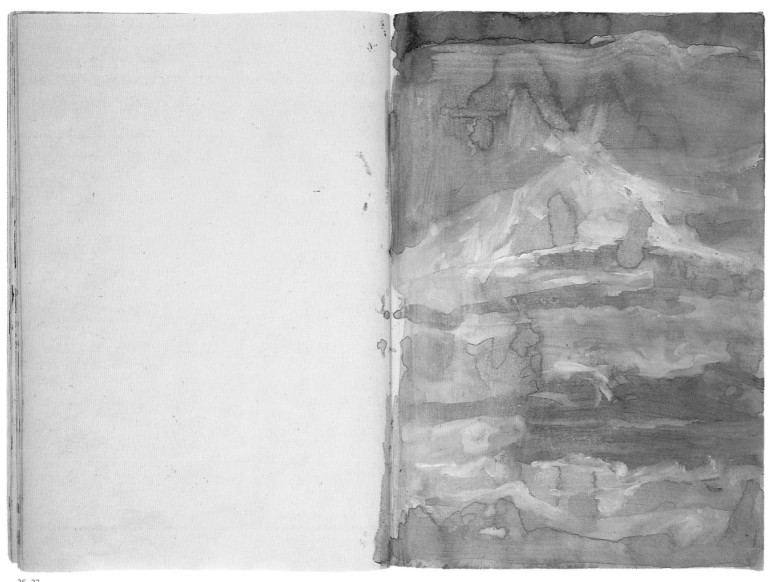

26–27

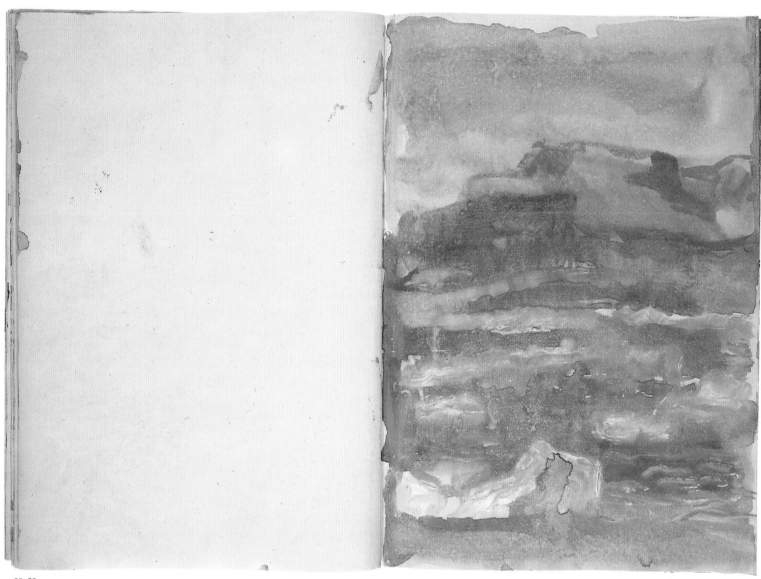

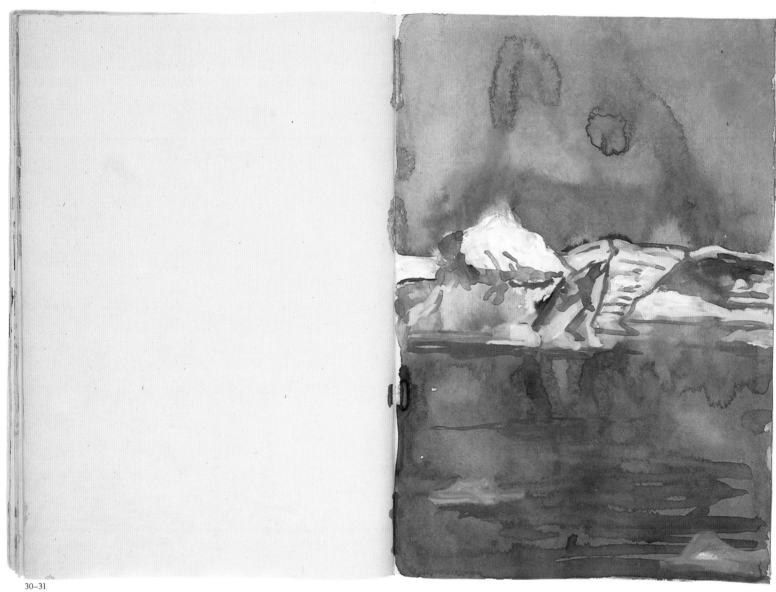

30–31

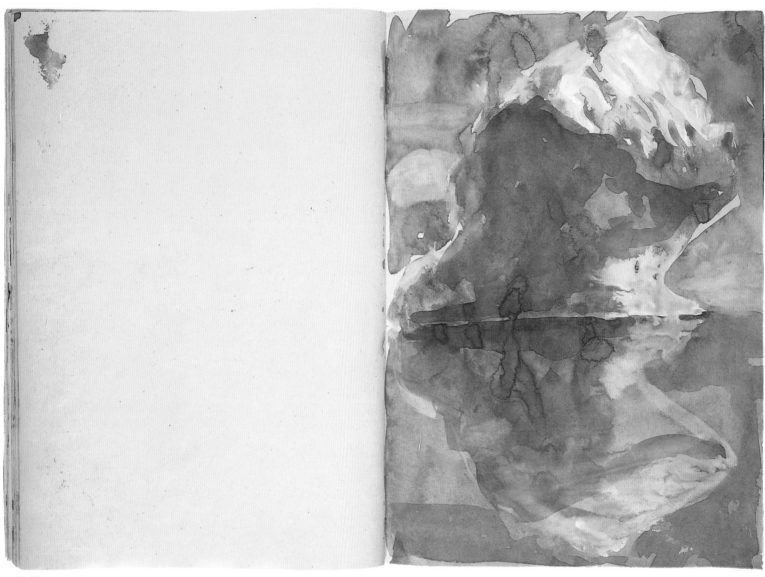

32–33

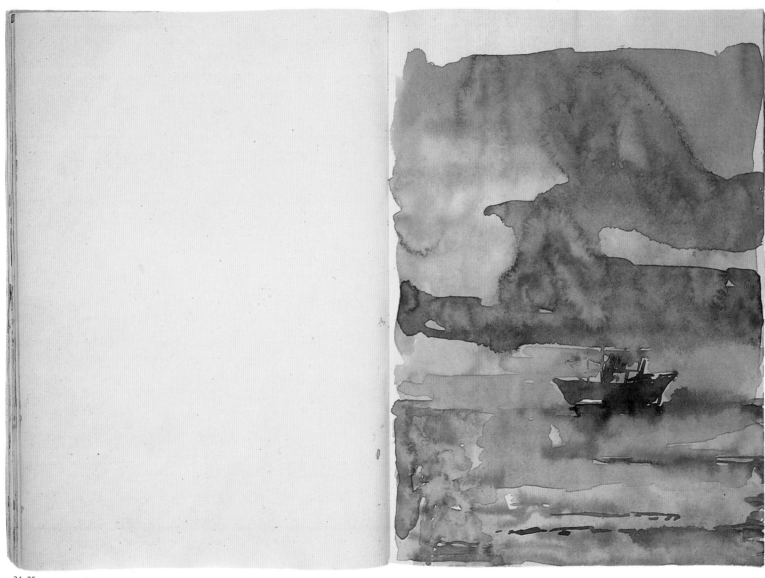

34–35

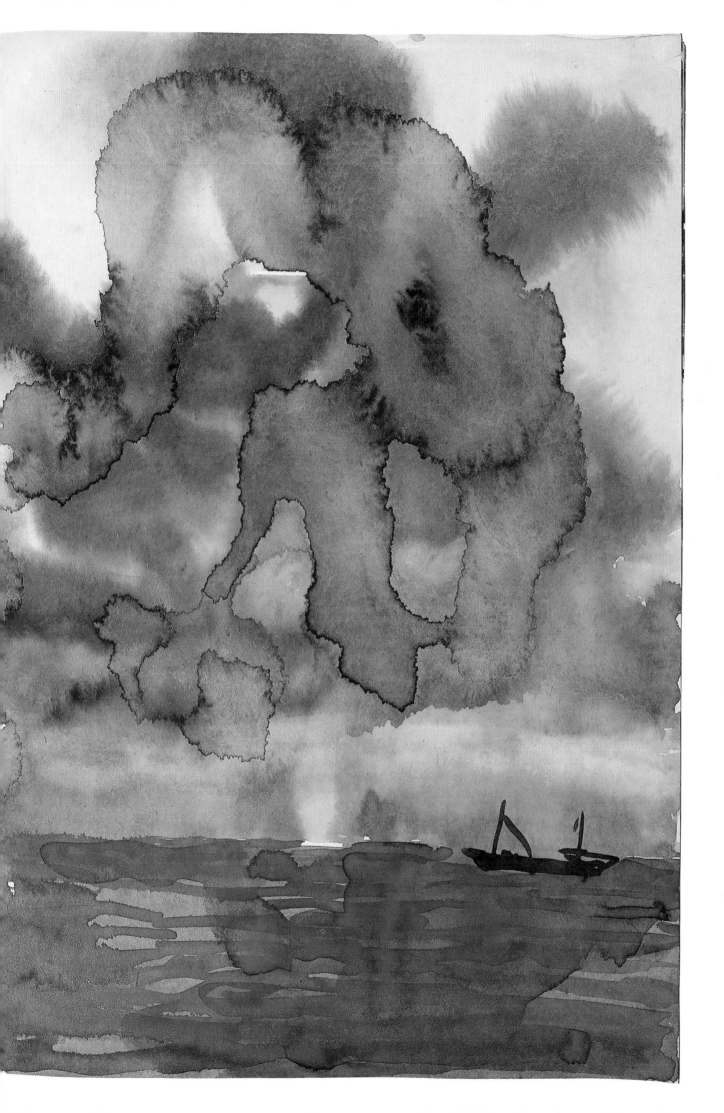

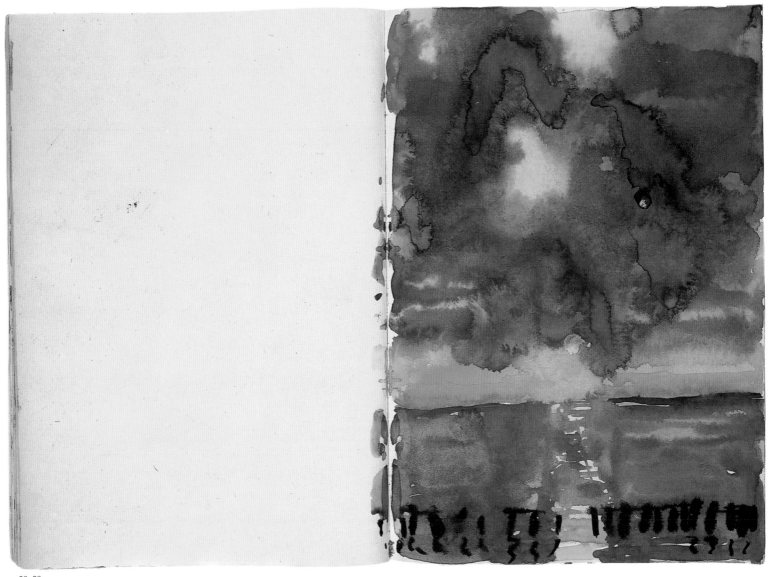

38–39

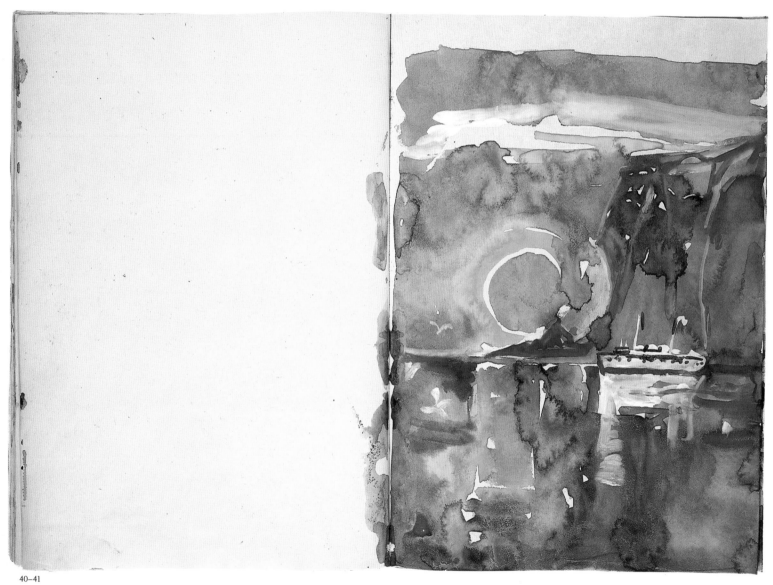

40–41

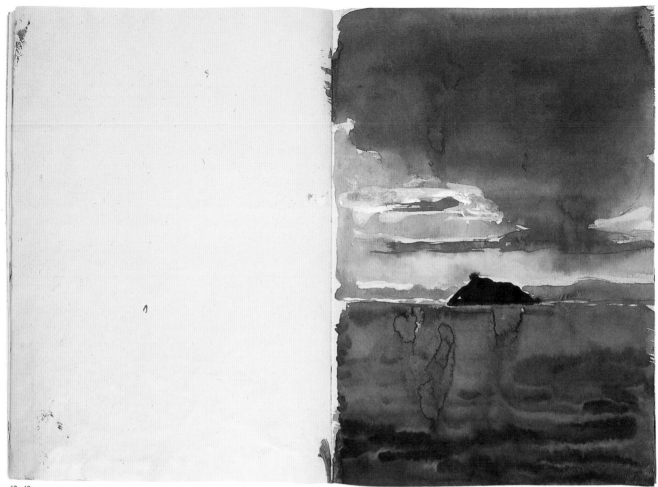

42–43

44–45

46–47

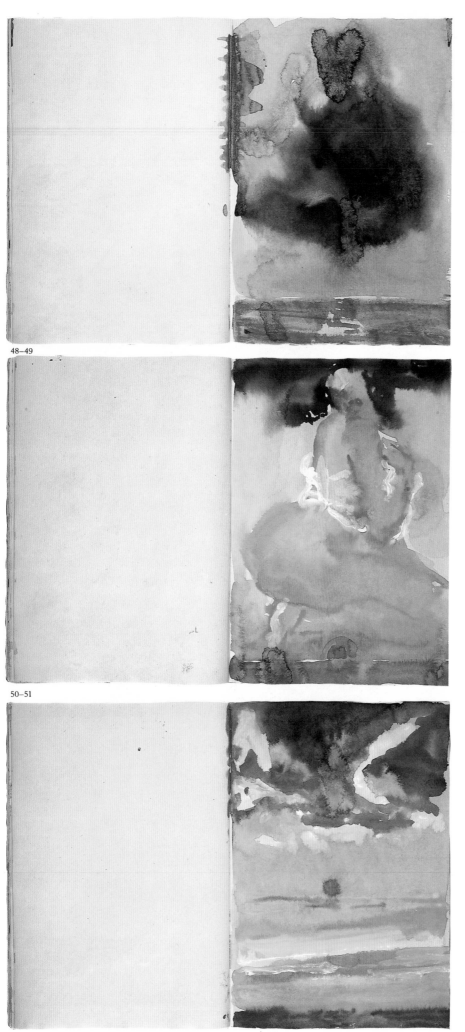

48–49

54–55

50–51

52–53

56–57

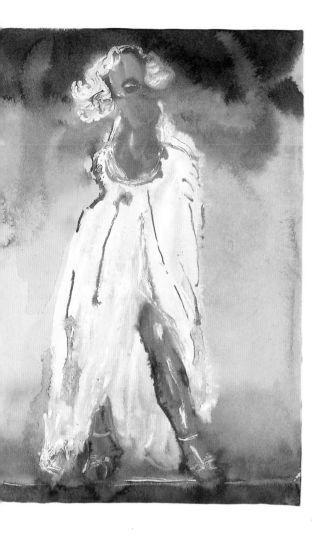

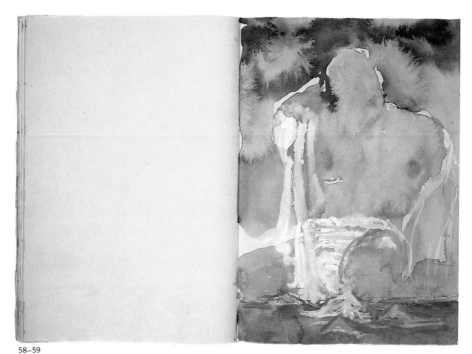

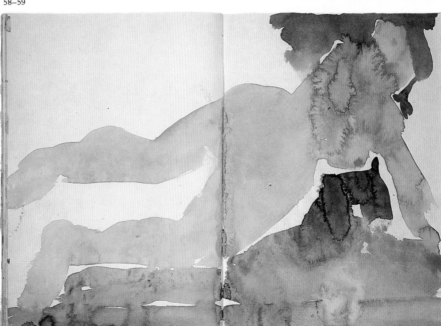

58–59

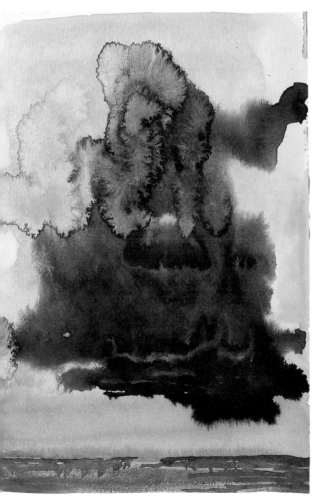

60–61

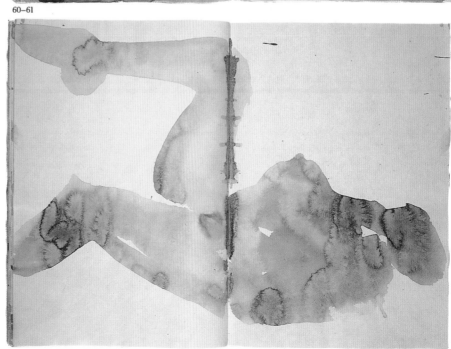

62–63

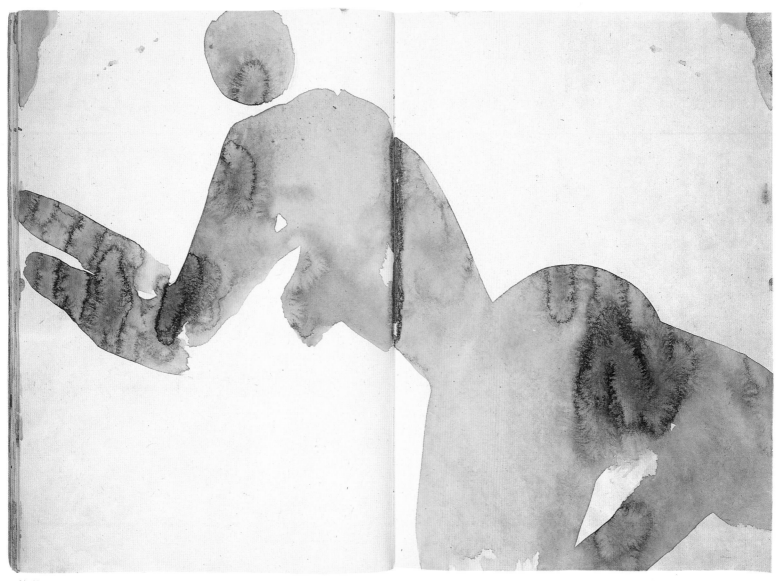

64–65

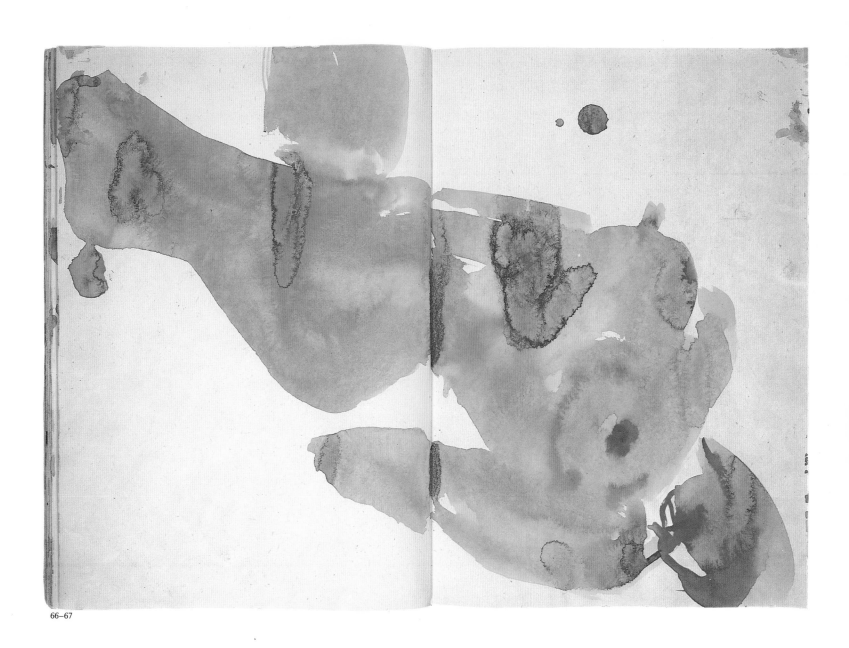

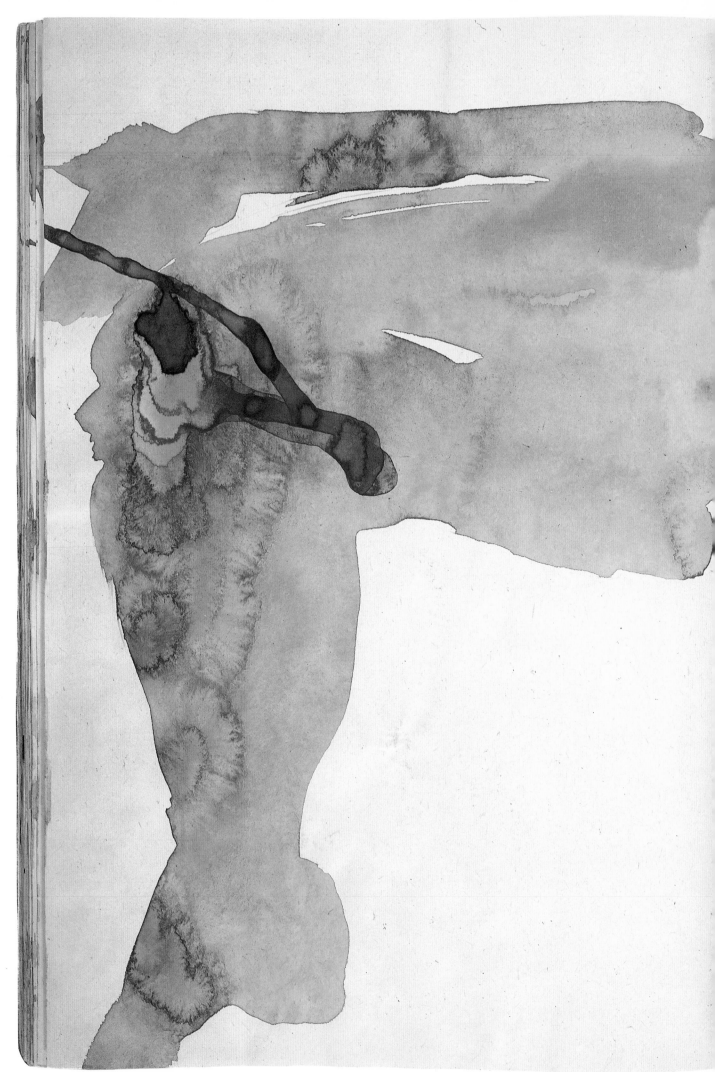

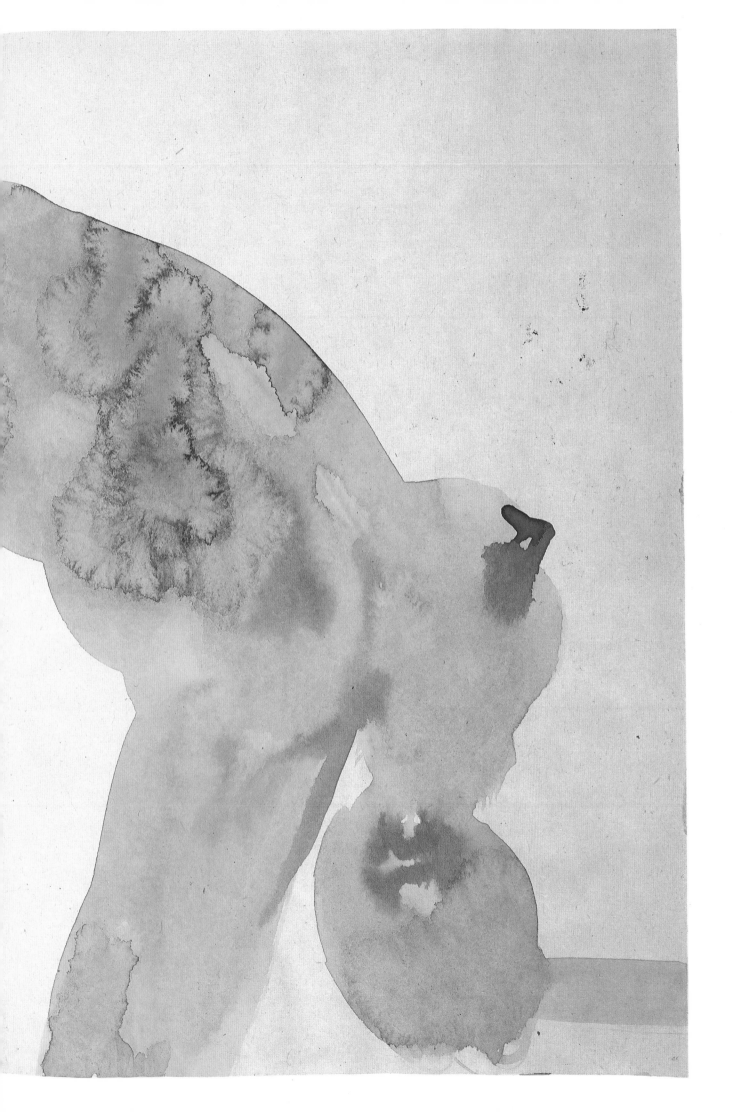

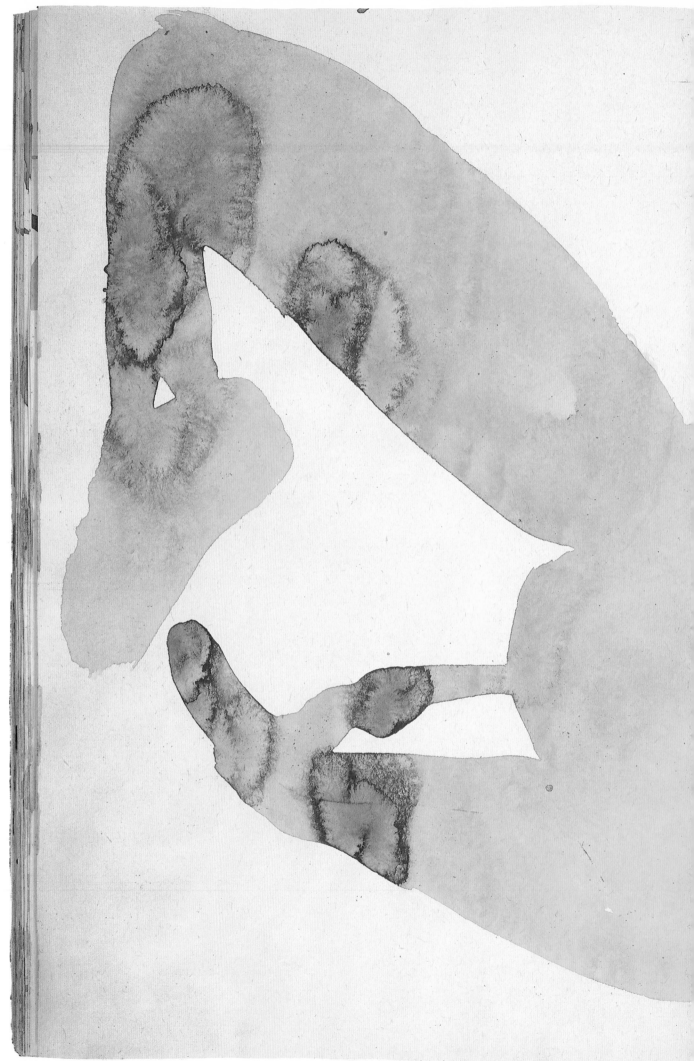

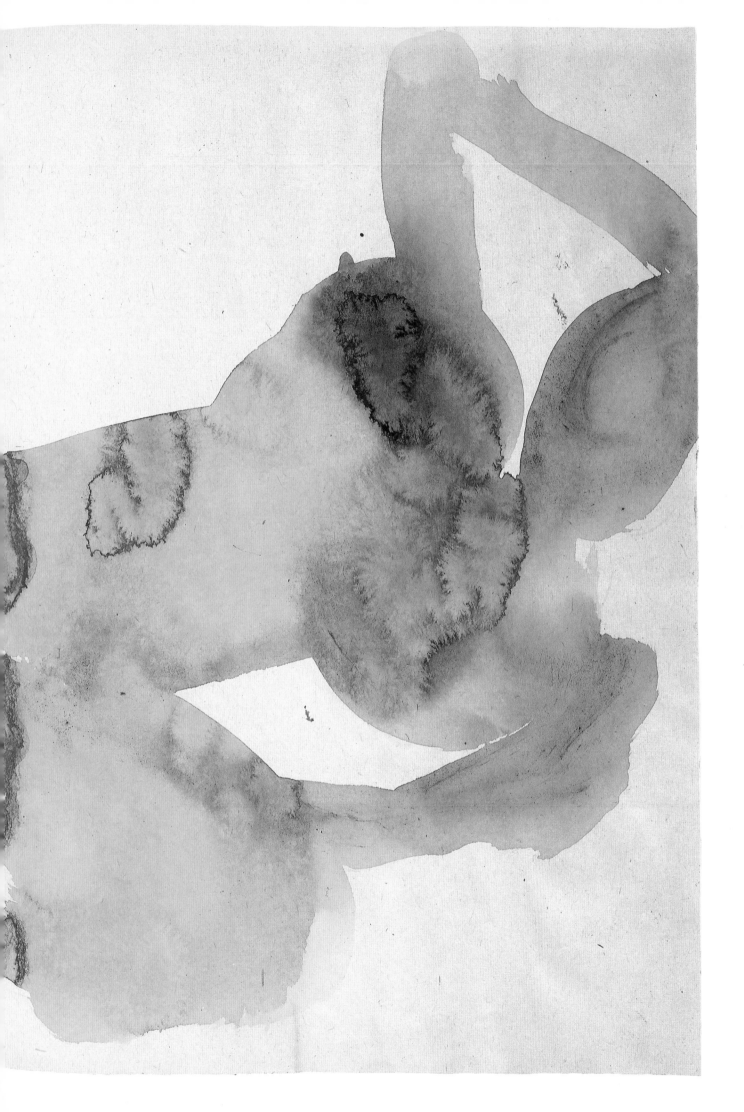

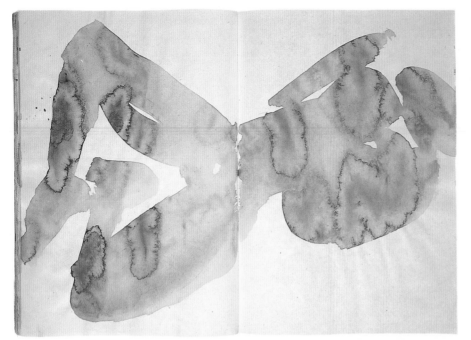

72–73

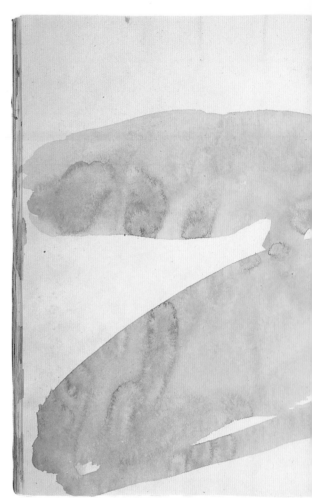

78–79

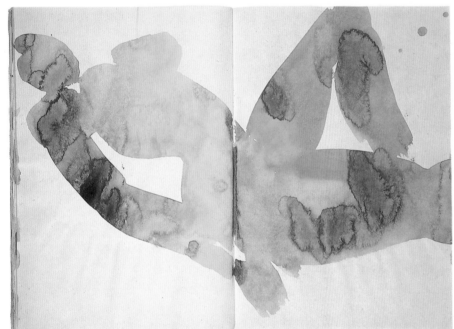

74–75

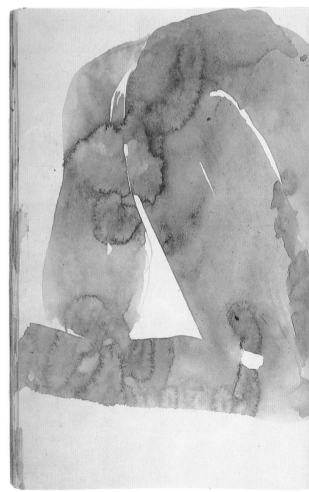

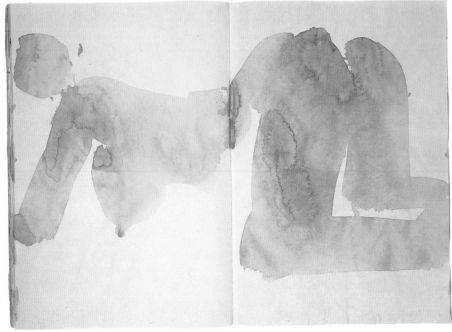

76–77

80–81

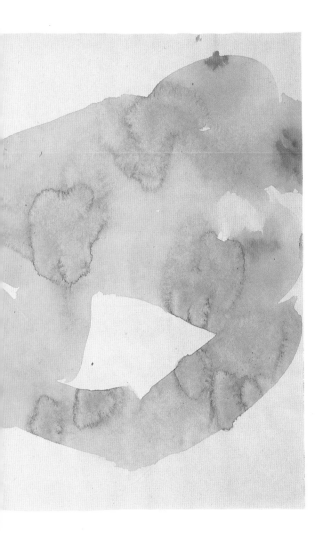

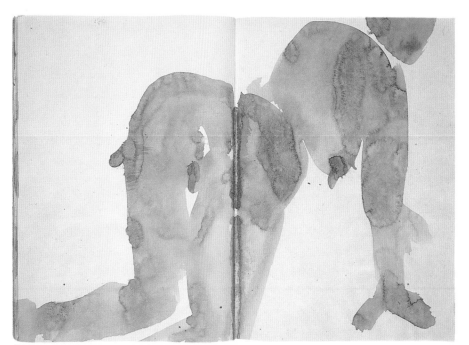

82–83

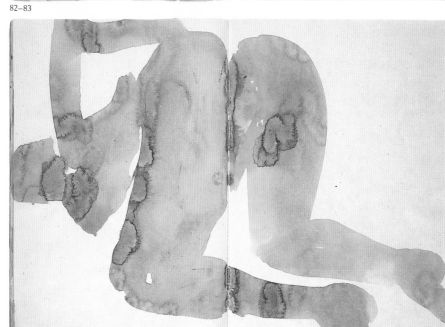

84–85

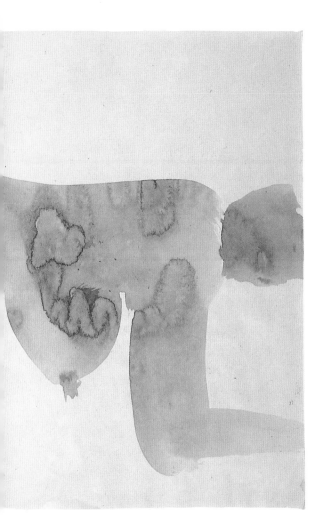

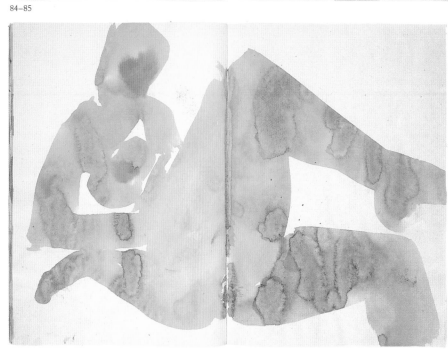

86–87

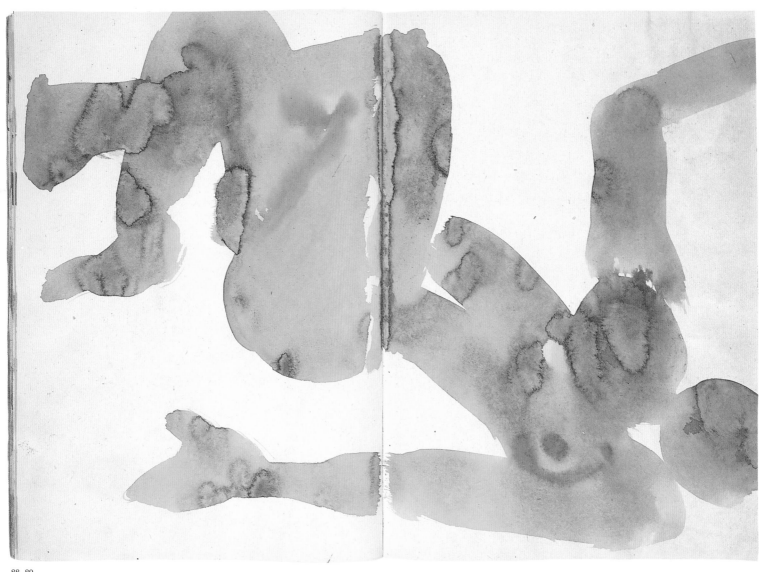

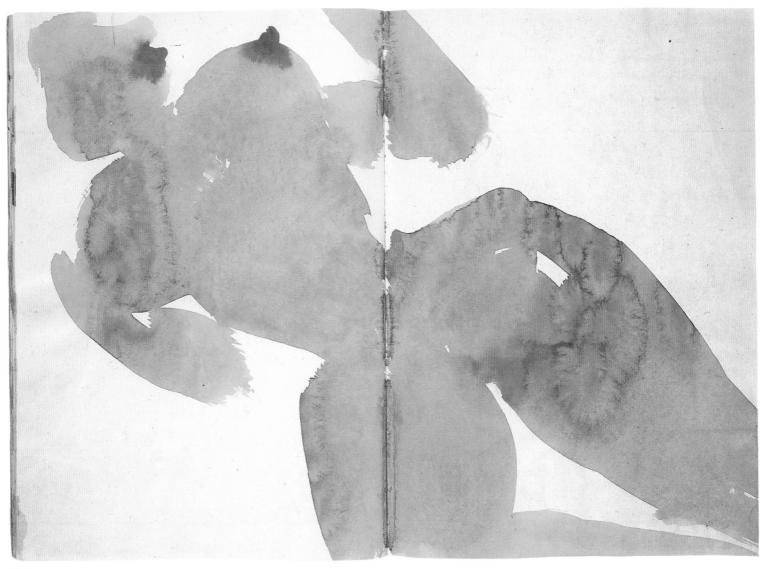

90–91

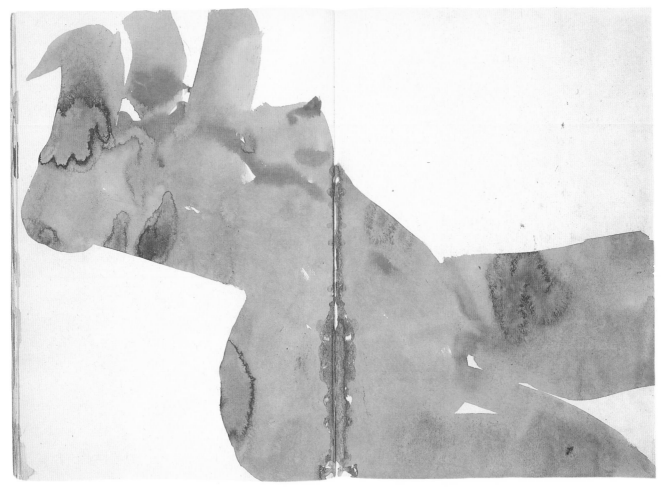

92–93

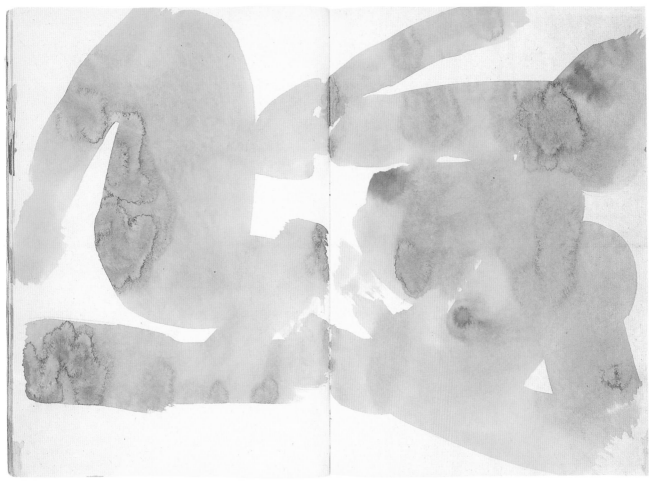

94–95

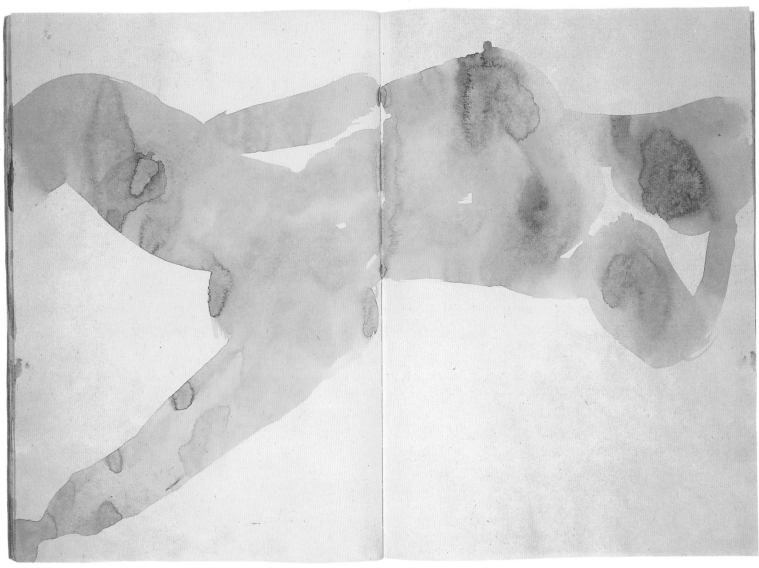

96–97

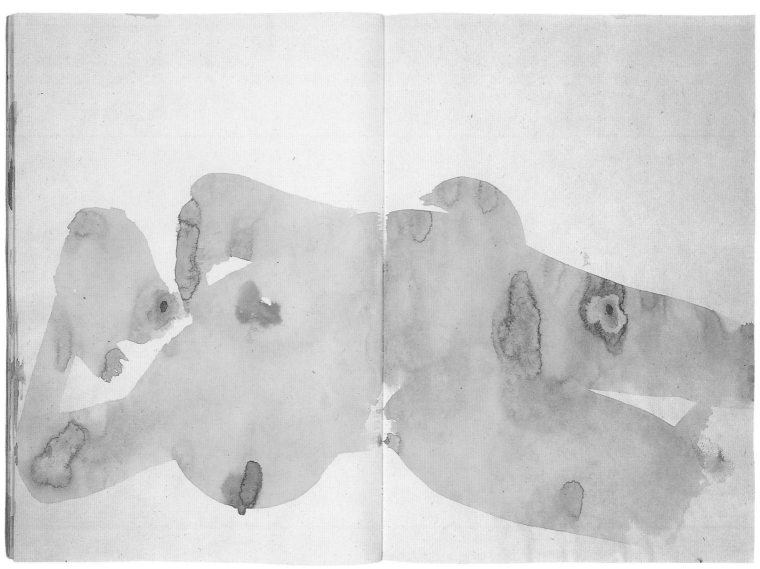

98–99

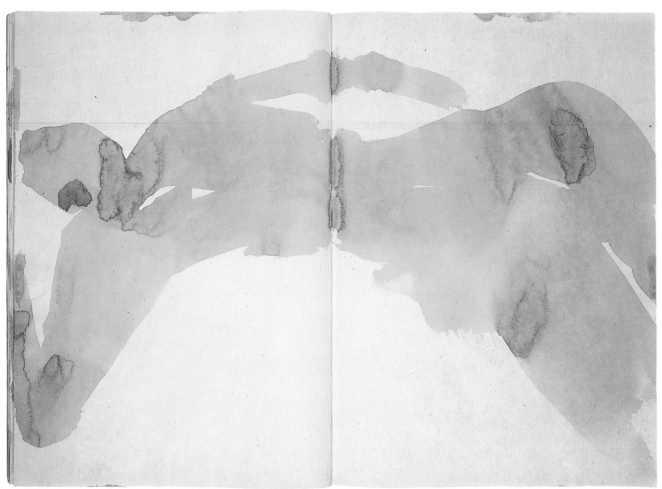

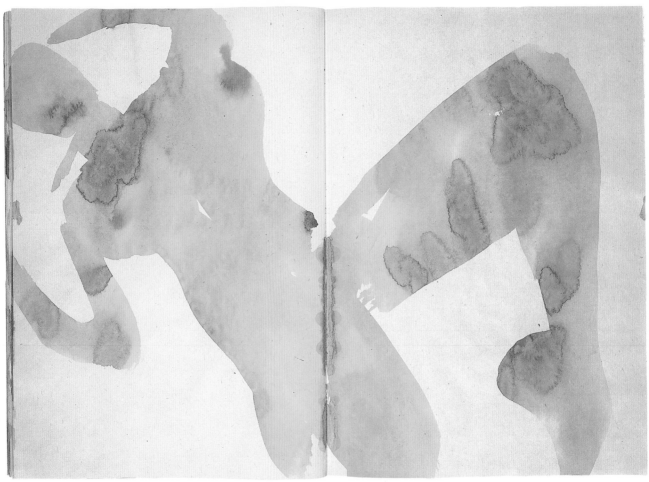

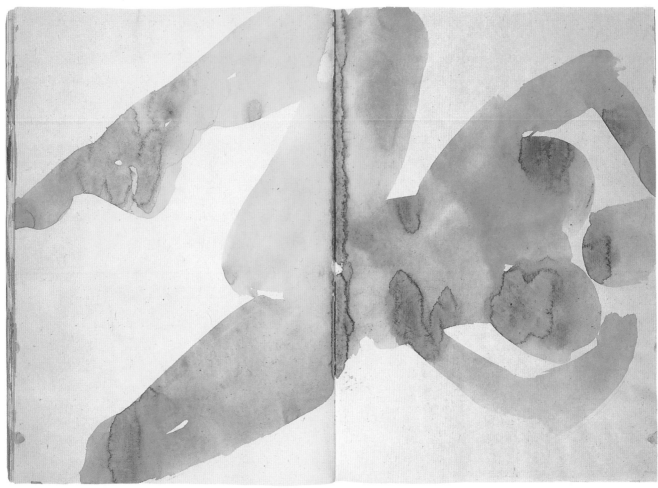

104–105

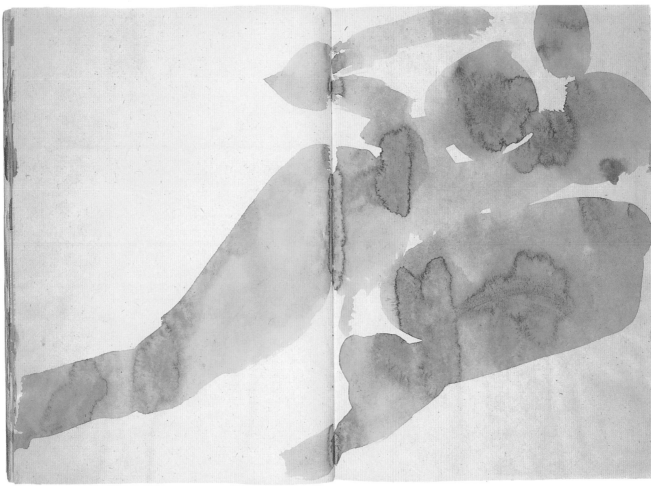

106–107

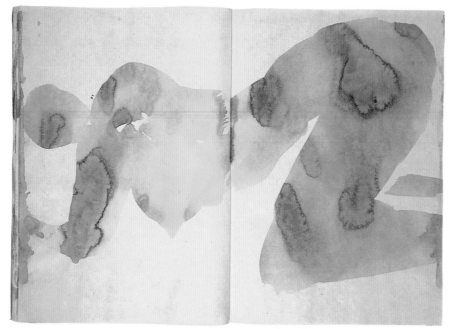

108–109

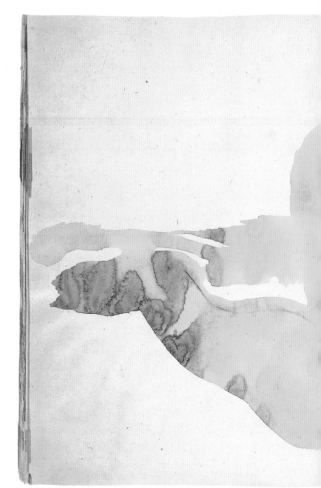

114–115

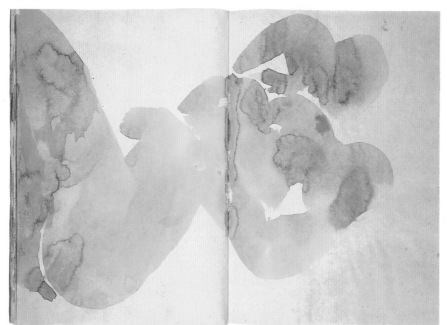

110–111

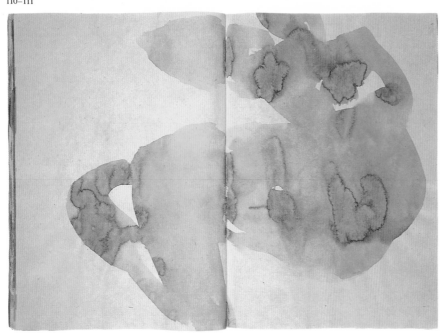

112–113

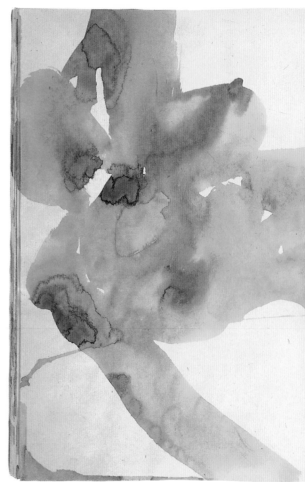

116–117

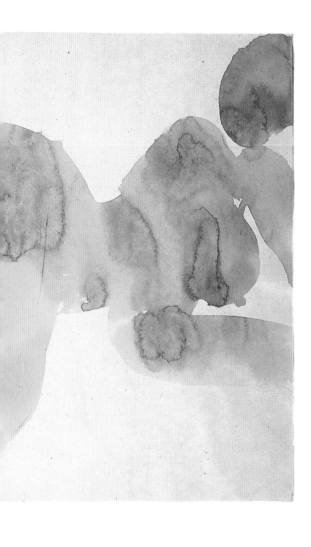

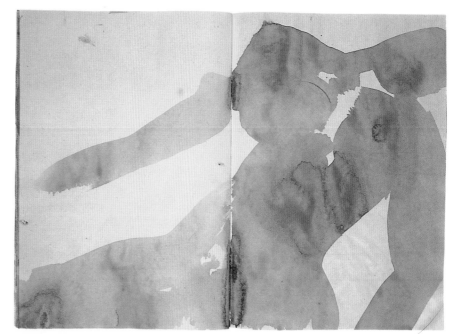

118–119

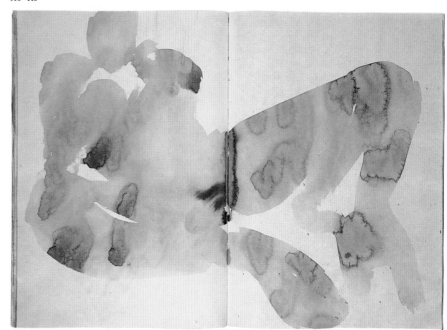

120–121

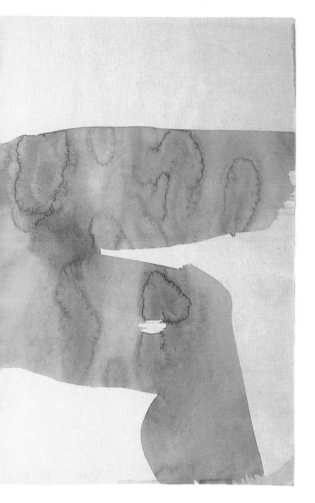

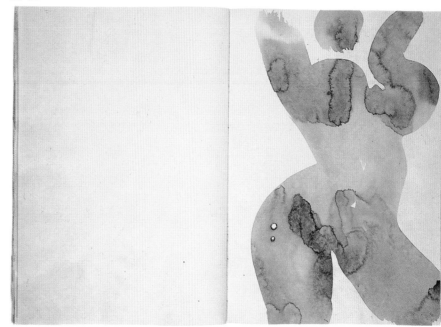

122–123

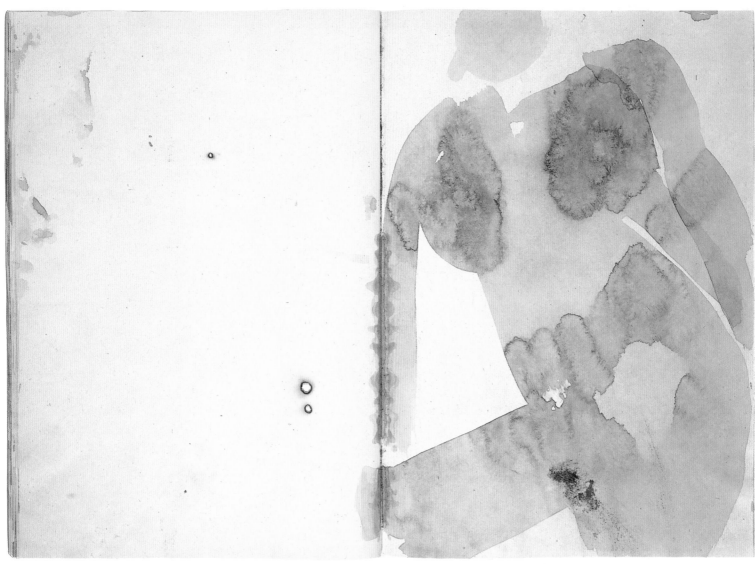

124–125

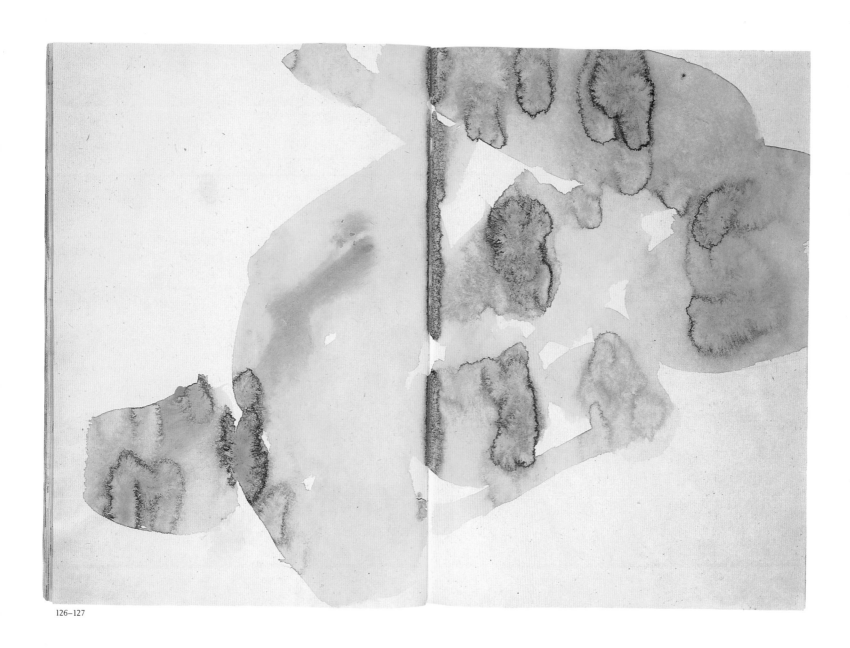

126–127

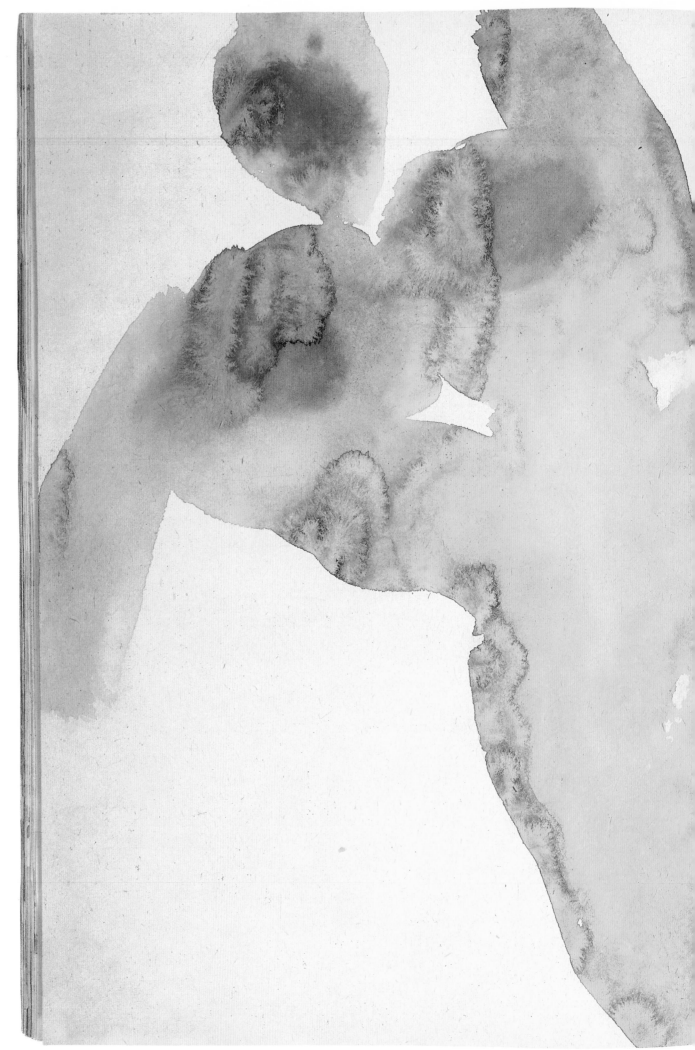

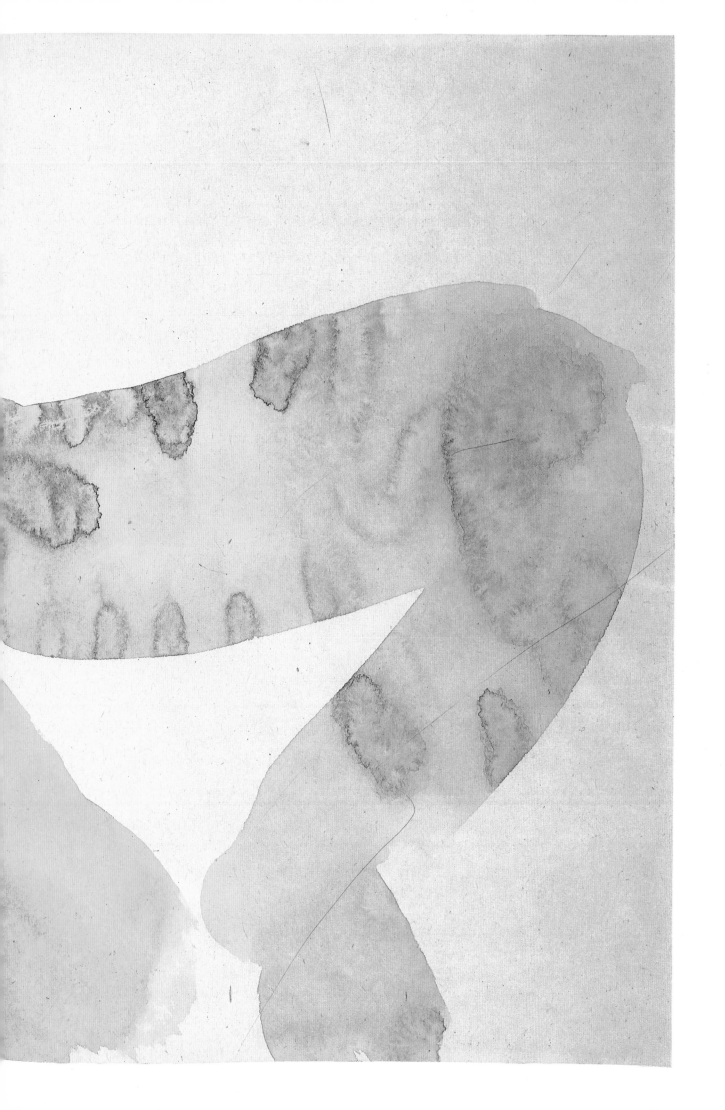

Back Cover